ART TECHNIQUES FROM PENCIL TO PAINT

BRUSH & COLOR

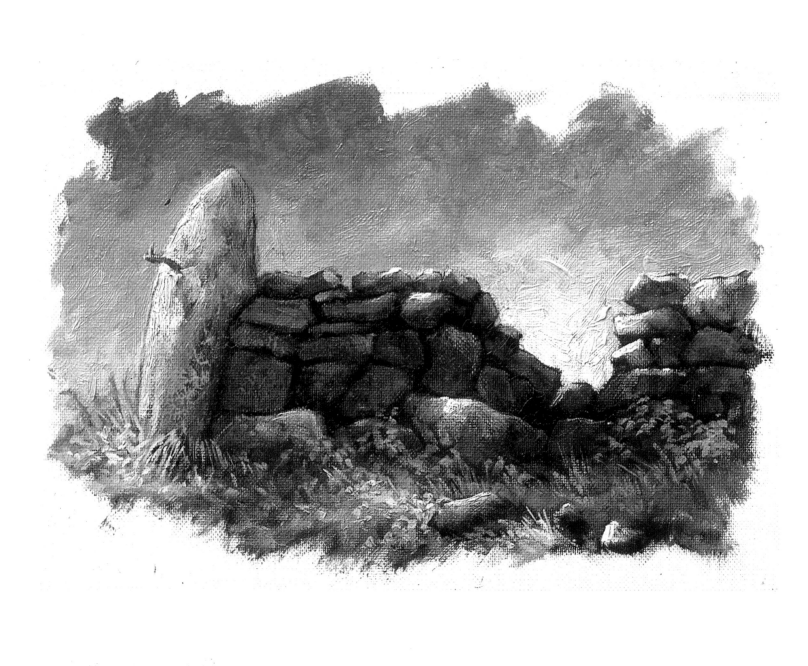

ART TECHNIQUES FROM PENCIL TO PAINT

BRUSH & COLOR

PAUL TAGGART

Sterling Publishing Co., Inc.
New York

Concept, text, illustrations and photographs © Paul W. Taggart 2002

Paul Taggart has asserted his rights to be identified as the author and illustrator of this work

Series concept and structure by Eileen Tunnell

© TAJ Books Ltd 2002

Library of Congress Cataloging-in-Publication Data Available

10 9 8 7 6 5 4 3 2 1

Paperback published in 2004 by Sterling Publishing Co., Inc.

387 Park Avenue South

New York, NY 10016

First published in Great Britain in 2002 by TAJ Books Ltd.

27 Ferndown Gardens

Cobham, Surrey, KT11 2BH

©2002 by TAJ Books Ltd.

Distributed in Canada by Sterling Publishing

C/o Canadian Manda Group

One Atlantic Avenue, Suite 105

Toronto, Ontario, M6K 3E7, Canada

Sterling ISBN 1-4027-0241-8

CONTENTS

The first steps into painting can be termed "sketching with paint," in which you begin to learn as much about the techniques of painting as you will about the subject. This should be a relaxed process, where much is learned through allowing things to happen. You need not worry if a sketch is left unfinished or even if you have taken it too far and it has become overworked. The main factor is the process of looking at and recording something from which you can either learn a new technique or be inspired to produce a more finished painting in the future.

Somewhere along the route to learning you will, however, wish to make a statement, pulling your new-found knowledge and skills together to produce a more finished work.

The pieces you will produce have a considerable significance, for they are stepping-stones in your progress. Rather than discard this early work, it is important to keep it as something that you can look back on to chart your progress. Seeing how you develop will do so much to build your confidence. A lot of the frustration experienced by those new to painting stems from the fact that they feel little or no progress is being

made, whereas every little improvement is a step forward. Looking back on early efforts will prove that all the little steps add up to some major leaps in your development.

As with all artists, you will never stop learning and improving, but what is important is the work you do at any one time, as it represents the knowledge you have acquired up to that point.

While it is difficult to see this at the time, each piece is a milestone in your artistic endeavors and has real value as a mark of progress. On looking back at some of my really early work, I wince at the inadequacies of the techniques employed in those days. The value of the work is never in question, however, when I consider the place it takes in the lifetime of work produced since then.

This philosophy forms the basis of the following chapters, which are not designed to show you works that are perfect but rather to demonstrate how techniques and ideas begin to come together.

The examples cover several media that require the use of brush and color, which is not necessarily paint alone. In each case, the result does not represent the pinnacle of achievement in each medium, for after all, there are a multitude of approaches that could have been exploited in each.

Instead, you will note that in each case the reason for using a particular medium in a particular way for a particular subject has been carefully considered. To link the medium, technique, and subject in such a way requires the final ingredient of experience.

Experience is an impossible element to quantify, as by its very nature it will be different for everyone. A painting is not a snapshot of reality; it is a snapshot of experience.

What goes through the eye percolates through the mind and soul of the artist. It is the artist's skill in translating that snapshot which enables others to share the experience. This language breaches any divide that may exist between age, sex, nationality, and social status. While the pen may be mightier than the sword, I believe the brush to be a little more generous.

Your journey through the following chapters begins with watercolors, combining a number of techniques, including Wet on Wet, Wet on Dry, and some Line and Wash. To top it all, a little creative texture is added to the mix in the use of plastic food wrap. A lot to use in one picture perhaps, but a lot of experience to be gained, and most importantly, it all works. Combine them with the stunning subject of a dragonfly in close up and there is plenty to keep you going in this study.

Turning to the use of acrylics, these are used to spotlight an animal portrait. Pets provide not only an easily accessible subject, but as members of the family, a study of one is immensely rewarding. Being a pet lover myself, I have always taken many photographs of my own, which have been put to extensive use over the years. But do not despair if you cannot take your own photographs; there are many in books and magazines that can be equally engaging.

Reproducing the fur or coat of an animal with its softness, structure, and color can prove a challenge and, when successful, a rewarding task. Acrylics are well up to the job as they can provide the softness when applied wet-on-wet and the rhythmic structure when applied wet-on-dry, while the layering of opaque paint provides body to the colors.

When faced with the rendition of sunlight, shadow, depth, and texture, there is nothing that fits the bill better than oil painting. The section on painting a stone wall takes you right through the entire layering process involved, providing all the answers to how to make the most of painting in oils.

In an oil painting you have to think ahead, anticipating how each layer will affect the preceding layers and those to come. Experience of painting in oils will provide this, but it is helpful to be given an overview so that you can determine exactly how every element in the procedure dovetails into another.

Since the application of pastels rarely involves a brush, you might imagine it would be difficult to place it in a book involving brush and color. However, an acrylic underpainting not only provides a dark surface key to which the pastel can adhere, but also textured brushstrokes. These brushstrokes are picked up and highlighted by the pastel layer, giving a painterly finish to the image.

The idea of crayons and a brush may also seem a little alien, but it is water-soluble crayons that form the basis of this demonstration. The popularity of watercolor pencils has led over recent years to the introduction of more solid means to apply generous dry color, which can be later dissolved with brushstrokes of water. The resultant qualities are quite unique and can be used on their own, as described in this section or combined with other media, such as watercolors, pastels, or acrylics.

Finally, we delve into the rich possibilities offered by colored inks. Inks often pose a problem in terms of mixing and creating values. The colors themselves are seductive in their depth and intensity, but are difficult to balance in the mix.

The problem is overcome by first laying the tones, followed by the colors. You will find an immediate affinity in the ease of application this offers and the muted colors that result.

Without successfully understanding and using color, you can never complete a painting with the verve and polish that you so ardently seek.

Since this book is about brush and color, the last section on color mixing offers advice on the way in which you can mix the media for each of the studies described and answers common questions like how to lay out your colors, which palette to use, and how many colors to choose — all of which directly affect the painting process.

WATERCOLORS

Introduction

Many years ago I was painting in a forest when something hummed past my ear. A sparkle of light caught fast moving wings, and I was drawn to follow the flight path of the dragonfly that had caused it. Grabbing my camera, I tried to get as close as possible to the resting insect. With no expensive lens at hand, I was faced with holding my breath as I trod judiciously across the foliage. The dragonfly remained unperturbed, staying long enough for me to take just one shot.

Ever since then the photograph has lain in a drawer, awaiting my attention. This is not unusual for I am always seeing things that take my interest as potential subjects for painting, often when I am not in a position to work them up immediately. This is where the camera comes into its own as a device for recording references.

What makes this subject even more poignant is the fleeting presence of creatures, such as this dragonfly, whose fragile beauty has long gone but remains as a lasting inspiration.

At the time of taking the original photograph, there was one aspect that slightly concerned me about the composition: how to treat the background. The insect itself provided a beautiful subject, with the patterns of color across its body and veined wings that cried out to be painted. However, dense ferns that clustered around the dragonfly swamped its transparent wings and very thin body. Something was needed to get me excited about all that foliage, and at the time the spark just wasn't there.

Time changes everything, for when I was playing around with watercolor textures for this book I suddenly remembered the photograph and everything fell into place. This was the chance to start with the problem area by working exciting textures for the foliage, thus eliminating the difficulty altogether. As soon as the answer to a problem is cracked at the outset, the painting almost comes to life on its own. The process becomes a joy, as your mind is open and receptive to letting the paint do a lot of the work for you.

Watercolor is a vastly underrated medium in one important respect: it never ceases to amaze me how many of those new to this medium believe that once something has been committed to the surface it cannot be subsequently changed or removed. My response is quite simple: were this so, I for one would never use watercolors.

The only principal dictate in using watercolors should be that of keeping it transparent. In this way, the color is almost luminescent as light passes through and bounces back from the white paper beneath.

If too much color is applied, which compromises the transparency, the offending color can, in most cases, be removed. Not only does this allow mistakes to be reversed, it allows us to use this as a technique in its own right.

Materials

1. Water Jar for cleaning brushes
2. Water Supply for paint mixes
3. Absorbent Paper Towel
4. Plastic Food Wrap for creating textures and covering and preserving wet paint deposits.
5. Flat Plastic Palette with wells
6. Ceramic Sloped Palette
7. Round Brush
8. Hake Brush
9. Flat Nylon Brush
10. Rigger Brush
11. Watercolor Paints In Tubes
12. Masking Fluid
13. Liquid Soap
14. Automatic Pencil 0.5mm 2B Lead
15. Kneadable Putty Eraser
16. Watercolor Paper

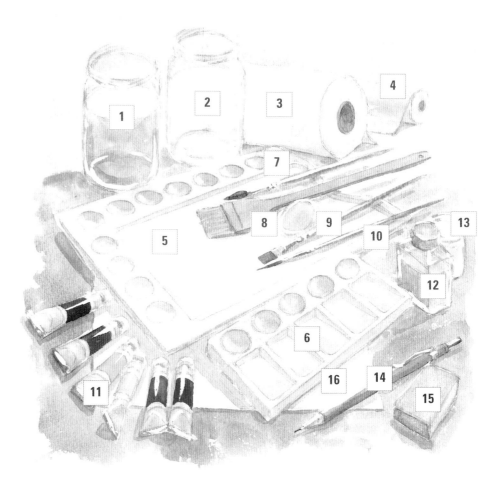

USING THE HAKE BRUSH

The Hake brush is at its most useful when applying large areas of water to the paper, where speed is essential for the Wet on Wet technique to work. Being made from goat's hair, the Hake is so soft it will not disturb areas of previously laid dry paint.

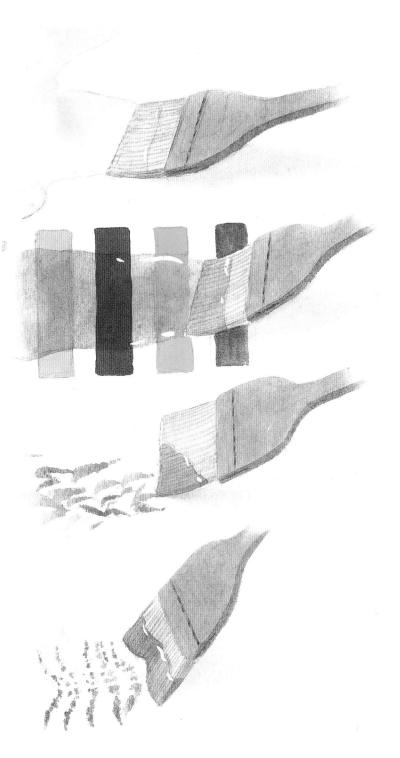

The Hake is also effective for laying large areas of colored wash. Again, its softness causes little surface friction, allowing dry underpainting to remain untouched. Underlying colors are unified by these bold washes. Imagine an area of paint with many disparate colors all fighting each other. One overlaid wash can bring them all closer, i.e. a dark and/or cool wash can cause a whole area of the painting to recede. With very large paintings, the Hake can be invaluable for blocking in large areas of light color, making subsequent brushstrokes easier to apply both physically and visually.

Loading only a corner of the Hake brush head allows some detailing and texture to be achieved. The less paint present on the head, the more these strokes will tend to scuff.

Having loaded the whole of the brush head, the soft hairs are pliable and retain shapes molded by your fingers. Irregular shapes, stipples, and strokes are possible using this technique.

Hints & Tips

OTHER WAYS OF APPLYING
IRREGULAR COLOR WASHES
The most important element of
this stage is the deep pool of
color mix containing lots of
water. This is applied liberally
with a Hake or other large
brush. In this step-by-step
tutorial, the color was applied
using a large No. 20 brush, but
you may prefer to be a little
more experimental and apply
some or all of the color using
other methods. Five methods are
shown here, but once you have
got to grips with these, it is
inevitable that you will want to
experiment with others.

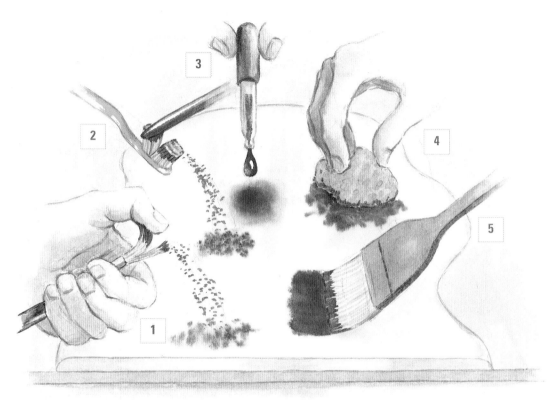

[1]Try splattering on the color
using a bristle brush. This
technique is gloriously messy,
but exciting and effective. Try
different densities of wash for
differing effects.

[2]An old toothbrush is effective
for spraying on thick paint. Use
your fingers or, alternatively, a
brush shaft or plastic ruler for
an equally effective result that is
cleaner to apply.

[3]Apply the color using a
dropper, to drop or squirt color
on from different heights.

[4]An artist's sponge will dab
textured color into the wet
surface.

[5]Finally, the Hake brush,
yields bold strokes of thick
pigment. Note that the Hake
holds a great deal of color, and
in order to get the best results,
you should ensure a good
quantity of color is mixed before
beginning.

MATERIALS

Stretched sheet of NOT Watercolor Paper

0.5mm 2B Lead Automatic Pencil

Nylon/Sable Round Watercolor Brushes - Nos. 6, 10, 20

Nylon Rigger brush No. 4

Watercolor Paints

2" (50mm) Hake Brush

Flat Nylon Watercolor Brush

Masking Fluid

Kneadable Putty Eraser

Step 1

Since the subject is so fragile against what is to become a powerfully textured backdrop, it needs protecting with masking fluid. Try to imagine that you are applying a color and be fluid with the defining strokes. Against the white paper, the masking fluid appears powerful and to cover a large area. Do not be fooled into applying too little. Once the white paper is given even its first layer of color, this balance will change radically, and the masked areas will appear to diminish in strength and coverage. Note how the composition is based on a grid created by these masked strokes. The dragonfly itself lies almost at the center of an off-centerd cross, created by the stems.

Hints & Tips

USING PLASTIC FOOD WRAP

Although by its very nature there is no absolute control over this technique, there are variations that you can devise to alter the finish.

In the first example, the plastic wrap is crumpled and laid into an even wash of color. Crumple the wrap before mixing and laying the wash so that there is no delay, which might allow the wash to begin to dry.

The second square shows the plastic wrap stretched before laying. Again, this can be shaped before mixing and laying. Both this and the previous method benefit from having a flat object, such as a book or a tile laid on top during drying. A small weight on top of this will further ensure the plastic makes maximum contact with the paper.

Finally, the wrap is simply dropped onto the wash, with no downward pressure applied.

NOTE
Allow plenty of time for drying before removing food wrap, which, being plastic, restricts evaporation and thus prolongs the time required.

Step 2

Lie the painting flat and prepare a good quantity of two washes. The first a yellow-green (Yg+bg) and the second a dark blue (Bp+bg+ro). Prewet the surface using the Hake brush and apply the colors boldly with a large (No. 20) brush. Drop on the plastic food wrap and allow to dry overnight. Inevitably, many of the effects are haphazard, but an effort is made to follow the structure, defined earlier with the masking fluid. Note for example how the plastic wrapping is bunched around the main stem and pulled across open areas. After that the rest is happenstance, so a little excitement in waiting for the result is well justified.

Step 3

If you do not possess the patience to wait until the next day, the paint will not have dried fully and the impact of the effect will soften. It is tempting to lift a corner, but do not; the wait is worth it when the resultant texture is revealed for the first time. Some results you will love, some you will be less sure of, while others will probably horrify you. It is the luck of the draw, but what an exciting way to begin.

COLOR MIXING

Where the prefix letter is shown in capitals this denotes a larger quantity of that particular color.

Conversely, where the prefix letter is shown in a lower case, this denotes a smaller quantity of that particular color.

E.G.

Bp= large amount of blue-purple.

bp = small amount of blue-purple.

COLOR REFERENCE

Red-purple (Rp)

Red-orange (Ro)

Blue-purple (Bp)

Blue-green (Bg)

Yellow-orange (Yo)

Yellow-green (Yg)

ARTSTRIPS

LIFTING DRY PAINT
Do not despair at poor lift. Not likely to be the technique. More likely that paper fibers have absorbed color.

Watercolor paper is sized. More surface size = less color penetration.

More penetration = less lift

For more aggressive lift, use tougher, less flexible brush, i.e. oil paint bristle brush

Do not rub surface to destruction. You will feel surface soften and then disintegrate.

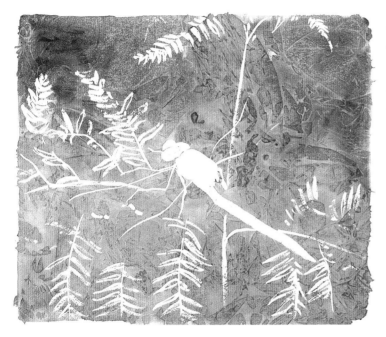

Step 4

When masking fluid is removed, the structure of the composition returns. Use the kneadable putty eraser to remove the masking fluid carefully and thoroughly, since the paint layer will vary considerably across the surface. Once again, the white paper dominates, but do not worry, the background textures will reassert themselves as the white is muted with color. You have now experienced the invaluable role masking fluid has to play, especially in this case, as such freedom in applying texture would have been impossible, while also trying to retain the highlights.

Step 5

Before rushing into applying more color, however, the dragonfly needs further protection. A second application of masking fluid to protect the lighter details in its sharp and highly patterned body will prove to be a great help. Use the flat nylon brush to lift off color and define the shape of the transparent wings, a hugely important aspect of the dragonfly. Lift-off is continued throughout the composition, softening some of the previously masked edges and creating soft lights elsewhere. Look for the extra leaves and continuations of the plant stem.

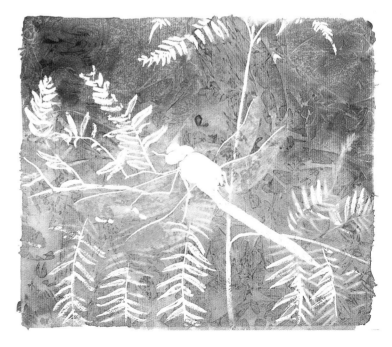

21

[A] Texture resulting from plastic food wrap dropped on wet surface.

[B] Texture from plastic wrap first crumpled and pulled before placing into wet wash.

[C] Counterchange (dark against light, light against dark) along wing edge.

[D] Sharp masked shape and edges.

[E] Sharp masked edges softened by lifting color after drying.

[F] Soft leaf shapes entirely created by lifting off after drying.

[G] Remasked patterns showing through overlaid dark graded wash.

[H] Gentle highlight color over masked areas.

[I] Gentle colors over lifted areas.

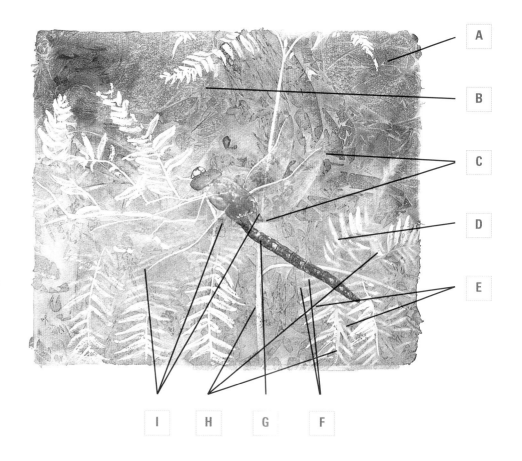

Step 6

Some gentle washes of blue-green over the leaves further softens their impact, allowing them to begin to meld with the textures behind. A more yellow-green to orange wash over the stalk of the fern defines its cross formation, while again allowing it to drop back into the composition. To add further definition to the wings, apply and then lose color washes at their edges. Note the very subtle counterchange along the wing edges. Apply wet-on-dry colors to the body and a graded color to the tail. The latter is achieved by laying a deep pool along its lower edge and wetting the area above, which allows the paint to flow.

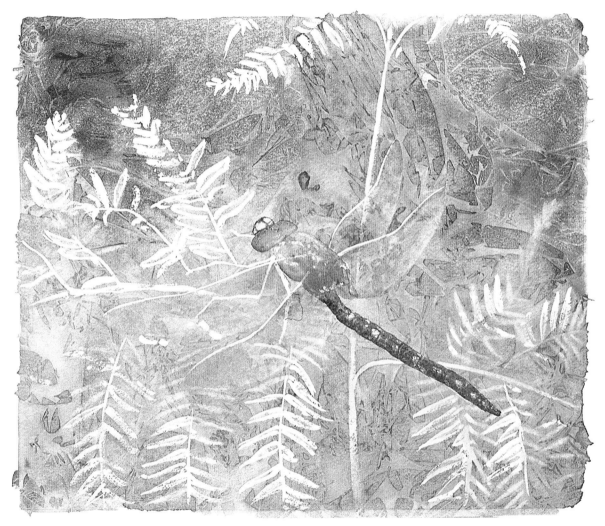

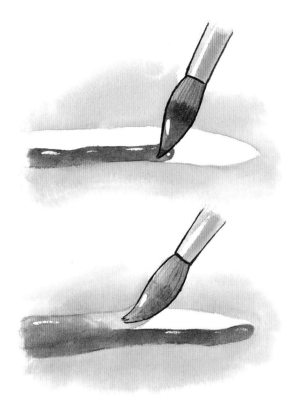

Hints & Tips

USING THE TIP OF A ROUND WATERCOLOR BRUSH
FOR LINE

Load the brush generously, but wipe and shape the point on the palette edge. Keep the brush held at a very steep angle to the paper surface. Support your painting hand if necessary to control the pressure as the line is drawn. The brush tip reacts strongly to differences of pressure, producing a varied line thickness that is very descriptive. The relatively large brush head enables a good amount of line to be drawn before reloading becomes necessary.

FOR MASS

For thin volumes, such as the insect's abdomen, first lay a deep fluid pool of color along its bottom edge. Above it draw a wet brush along so that the color runs naturally across the wet surface until it finds the top dry edge. As long as both areas remain wet, there should be no need for brushing to move the color.

Step 7

Using the tip of the brush point, paint the green edge to the leaves. This produces a line that is quite different from the one created by a small brush or a rigger. Here there is more definition as the gentlest of pressure variations causes extreme differences in line width. Probably due to the amount of paint this larger brush can carry, the result is a quite calligraphic feel to the silhouette. Add more water to lighten the linework beneath the wings. Once you are relaxed and confident with the free line, carry on into the body of the insect with blue-black, using the brush point with the same freedom.

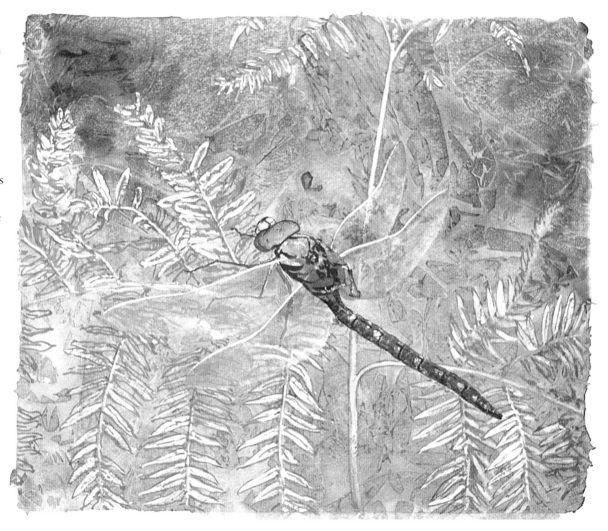

ARTSTRIPS

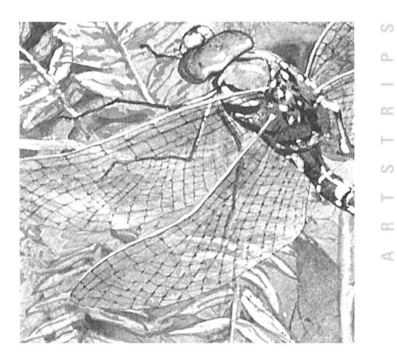

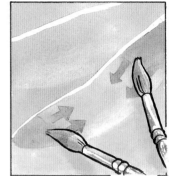

Lift off color along wing edges.

Or, use dark washes. Apply hard at wing edge and lose into wing interior.

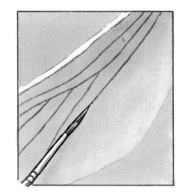

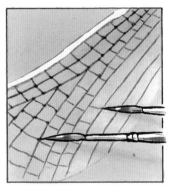

Draw veins along the length of the wings first...

...then add cross-members and reinforce the join as vein meets vein.

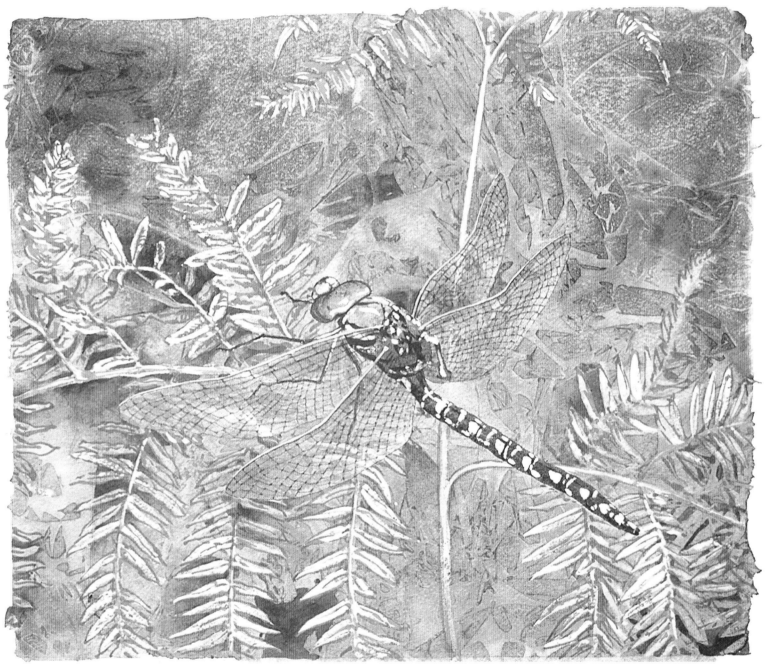

Step 8

Remove masking fluid with the kneadable putty eraser and apply highlight colors to the body and wing struts. The fishnet effect of the wing veins is created by first drawing in the veins that travel the length of the wing, using a Rigger brush. If you do not feel confident enough to do this freehand, there is no reason why you should not draw them in gently with pencil first. Once in place, paint in the connecting veins between lines. Where the veins join, reinforce the joint with a tiny spot of color. Although miniscule, you will be amazed what a difference this makes. The final balance and link between the leaves and the background texture is made by stepping back and after considering the balance of light and shade throughout, blocking some negative dark areas to add some final contrast.

Introduction

The enticing element of painting with acrylic paints is the feeling of painting with liquid plastic. While the pigment is the same as that used in other media, the medium in acrylic paints is a liquid polymer.

Acrylic paint dries as a plastic membrane in which the pigment remains embedded. As such, it is incredibly strong, can be adhered to a multitude of surfaces without prior preparation, and can itself be used as glue in which to embed relatively heavy items.

As it is fast drying, reworking can be carried out swiftly and once dry, will not re-dissolve. Layers of color can therefore be overlaid with no danger of bleed through, enabling you to work light colors over dark with a great deal of freedom.

Some acrylic paints have a more fluid consistency than others, and these are better suited to watercolor techniques. Others possessing more body, create impasto with greater ease, but often require the addition of various pastes to achieve still bolder textures.

Glazing is also an option, where extra medium added to the mix thins out the pigment, making the paint layer much more transparent on drying.

While it could be concluded that acrylic paints offer an alternative to oil painting and watercolors, it would be truer to say that acrylic paint should be treated as a medium in its own right, with qualities unique to itself. When these are mastered, they will provide an additional weapon in your armory of techniques and media.

Because of its fast drying characteristic, it may appear that the most natural way to work with acrylic paint is to build up a succession of wet-on-dry strokes. Working in this manner creates sharp, focussed, almost static images, and while this will suit many subjects, it is also often essential that softer atmospheric brushwork is brought into play.

In watercolors, the technique employed would be that of Wet on Wet, which can be directly applied to acrylic paints. This approach, together with the use of stable, opaque layers provides a means of working from soft darks to sharp highlights. Highlights may also be raised from the surface as impasto paint that catches the light, thus adding an oil painting technique to the repertoire.

The following step-by-step tutorial takes a subject that benefits from exploiting these various qualities. Painting animals always involves dealing with feather or fur. While some parts of an animal's coat require sharp individual features, others need to be kept soft and fluid. Movement and depth have to be considered alongside the variations of texture and color.

Wet-on-wet acrylic painting provides all of these properties, with a surface that can be rewet and repainted again and again until the results prove satisfactory.

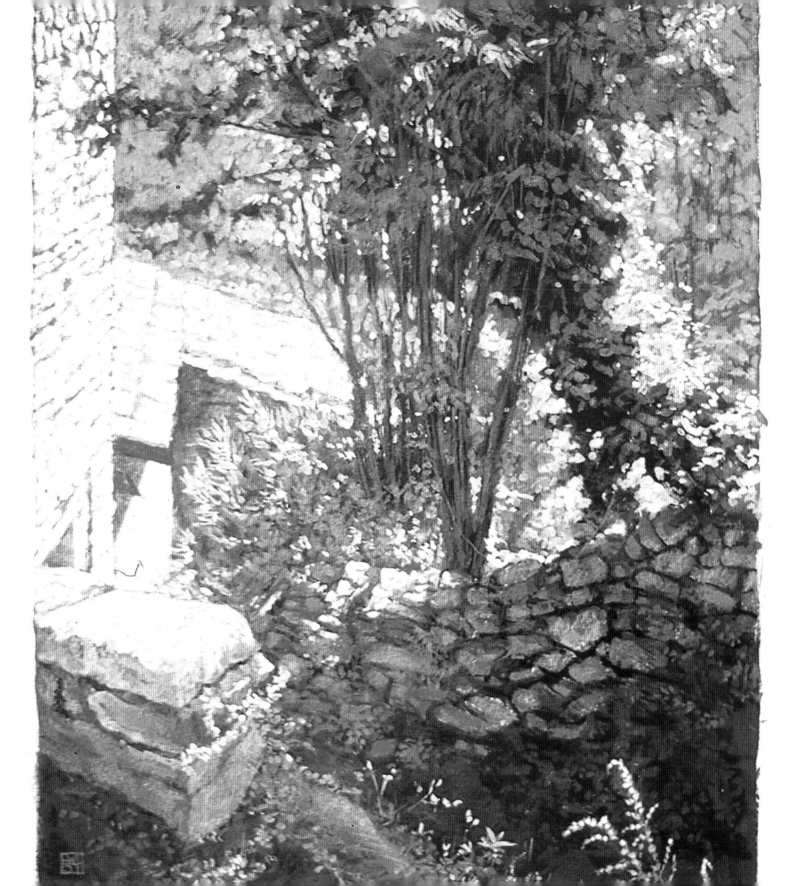

Materials

1. Acrylic Paints in Tubes
2. Various Painting Surfaces (Primed & Unprimed)
3. Automatic Pencil 0.5mm 2B Lead plus Kneadable Putty Eraser
4. Stay-Wet Palette
5. White Acrylic Paint
6. Modelling/Texture Paste
7. Volume Paste
8. Nylon Rigger Brush
9. Nylon Round Brushes
10. Hake Brush
11. Palette Knife
12. Mini Jam Jars with lids (to squeeze paint into)
13. Acrylic Gloss Medium
14. Acrylic Matt Medium
15. Acrylic Gel Medium
16. Retarding Medium
17. Brush Washer
18. Jam Jars for Water
19. Plastic Squeeze Bottle (to hold water)
20. Absorbent Paper Towel

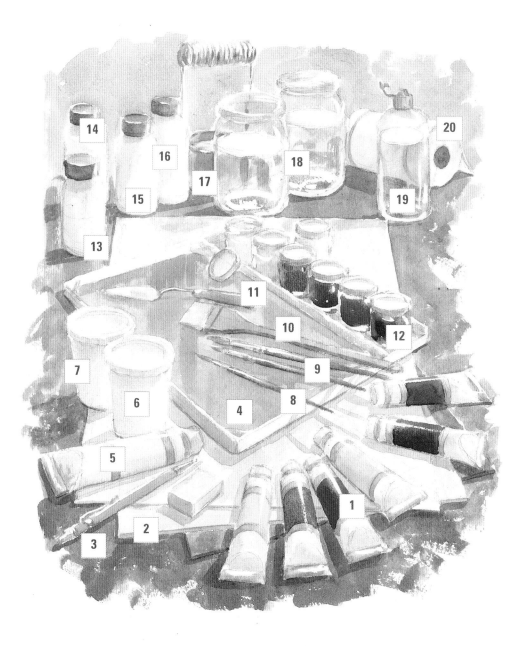

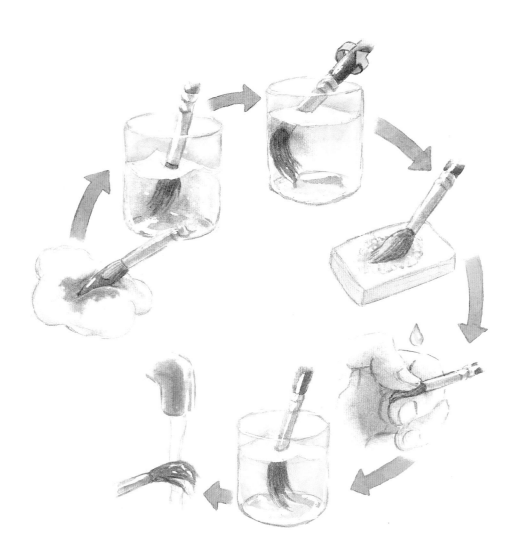

BRUSH CLEANING

Absolute cleanliness and vigilance is essential when using acrylic paints. Provided you care for your brushes, this medium is extremely manageable and even pliant to your needs. The problem lies in its inherent strength. As the paint dries, a plastic film develops, which glues the pigment to the surface.

If your brushes are only partially cleaned, a weak solution of acrylic paint may be left behind. Once the water evaporates off, the solution left in the brush becomes thicker, and even a small amount will glue the hairs together into a solid lump.

It is far better to over wash the brush than to chance any acrylic being left behind. First, wipe the brush in a tissue to remove the bulk of the paint. Remove the rest by swishing the brush in a jar of water.

To get the paint out of the base of the brush hairs, place in a jar of water and push the brush head against the side of the jar; then rotate gently. Remove from the jar of water and work soap into the hairs by either rubbing them over a bar of soap or working liquid soap in to the hairs with your fingernail. Place in a jar of water, push against the side, and rotate. Repeat these two steps until you are confident the acrylic paint has been fully removed.

CAUTIONARY NOTE
Never put down a brush with even a drop of acrylic paint in its head. Transfer it immediately to a brush washer or the wet surface of a stay-wet palette.

Always use cold water to wash brushes, as hot water damages the brush head.

Hints & Tips

PAINTING ANIMALS & CHILDREN

Many performers do not like working with animals or children for one simple reason: being cute, they usually steal the show.

One characteristic that makes them so is their inclination to tilt their heads. While this may be endearing, it can easily throw out all the features across the face. There is a simple method to help you deal with this. Hold up a pencil so that it passes through both eyes. This will enable you to immediately identify the angle of tilt of the head. All the other features will now reflect this angle.

Another characteristic to deal with is that of the heads of children and young animals, which differ from adults in that they are larger in proportion to their bodies. We respond emotionally to this without even recognizing the reasons why. Check the depth of the head with your pencil and see how many of these lengths will go into the body. This will often surprise you, but get it wrong and the child or animal will look older.

Materials

Stretched sheet of NOT Watercolor Paper

0.5mm 2B Lead Automatic Pencil

Nylon Round Watercolor Brushes, Nos. 6 & 12

Nylon Rigger Brush No. 3

2" (50mm) Hake Brush

Acrylic Paints plus White

Kneadable Putty Eraser

Step 1

The pencil drawing and any erasing can be carried out quite aggressively since the overlaid acrylic paints will be in the most part opaque and will strengthen the paper surface. Check the vertical line of the figure through the eyes, nose, and legs to ensure the correct balance is achieved through everything being aligned properly. Just as in a human portrait, more time is required to achieve the likeness of a particular dog. Treat the interlocking curls of the coat as jigsaw shapes to correctly render their proportions and rhythms. The negative spaces behind and around the animal are important not only for compositional balance but also to give breathing space for this subject.

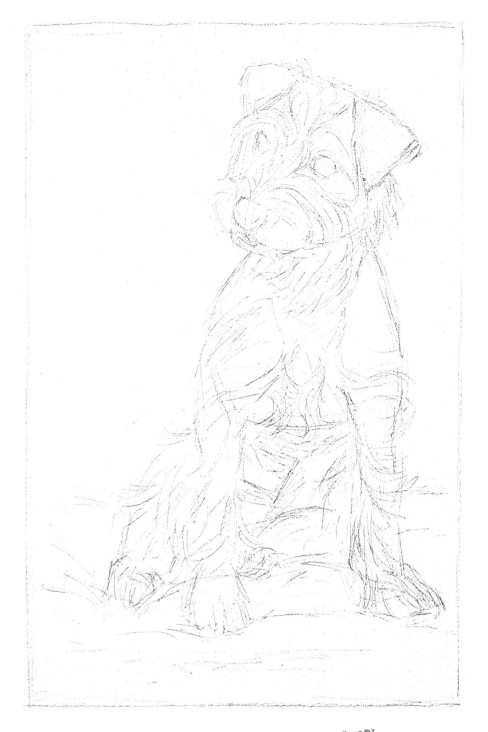

A R T S T R I P S

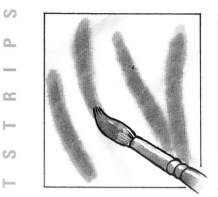

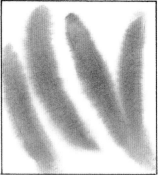

Initially heavy acrylic paint remains brushy in the wet surface.

But there is some spread as the surface begins to dry.

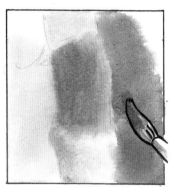

First colors always appear dark against the white of the paper.

Only when surrounded by others does its true value become apparent.

Step 2

Wet the entire surface with a well-loaded Hake brush and block on broad areas of soft color, eliminating as much as possible of the white paper. In watercolor painting these would be highlight colors, but here, where we are going to layer dark to light, they can be a series of colored grays. You will not need to worry about achieving exact hues, but try for correct values. As the white disappears, however, these will change. Keep colors in these grays, warm or cool, and avoid absolute neutral grays. Acrylic wet-on-wet has a different feel to watercolor. There is much less spread and movement of the pigment, and so it is well suited to working upright. After application, the strokes remain brushy, but the color does spread slowly as it dries, something that must be taken into account if you are used to the immediate response of watercolor painting.

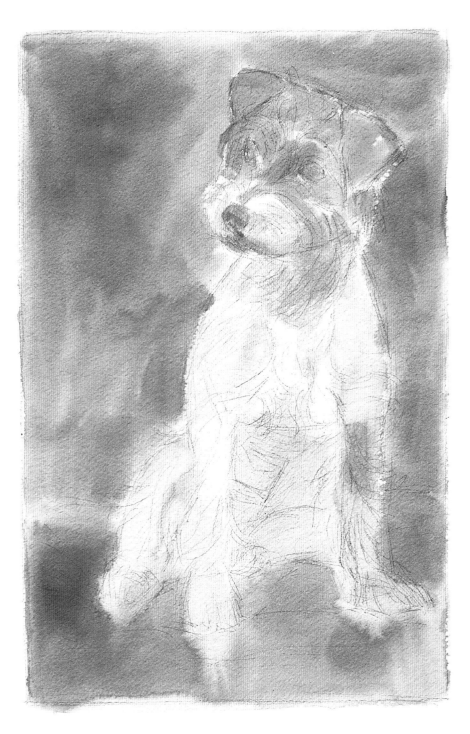

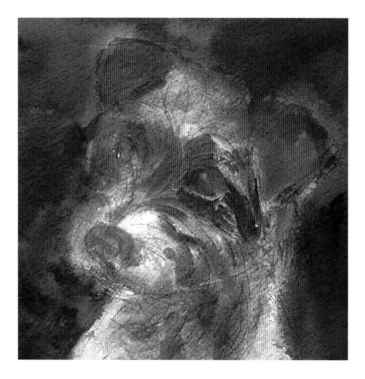

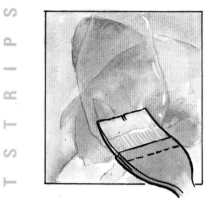

Rewetting small areasof dry paint....

...allows values to be corrected and rebalanced while retaining soft edges and focus.

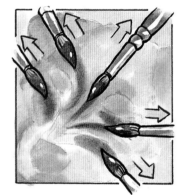

Draw brush in direction of lie of the fur to begin to describe its rhythms and movement.

For focussed wet-on-wet, rewet with large round brush and use small round brush to detail with stiff paint.

Step 3

Having established the soft contours, it is time to correct the drawing with brush and color. Rewetting the surface with the Hake presents no problems, as the previous dry layer of color will not lift. Work on small areas, however, to ensure the surface is kept wet as it is reworked with darker/denser color. Working on a controlled patch allows more work to be done, adding detail until the drying surface dictates you must stop. You must stop as soon as hard edges begin to appear. Move on to work on another area and only return to wet and rework the previous area once it has dried. As acrylic dries quickly, you won't have a long wait. Colors are made more exciting by layering warm grays over cool and vice versa. Note the colors in areas of fur that are supposedly white!

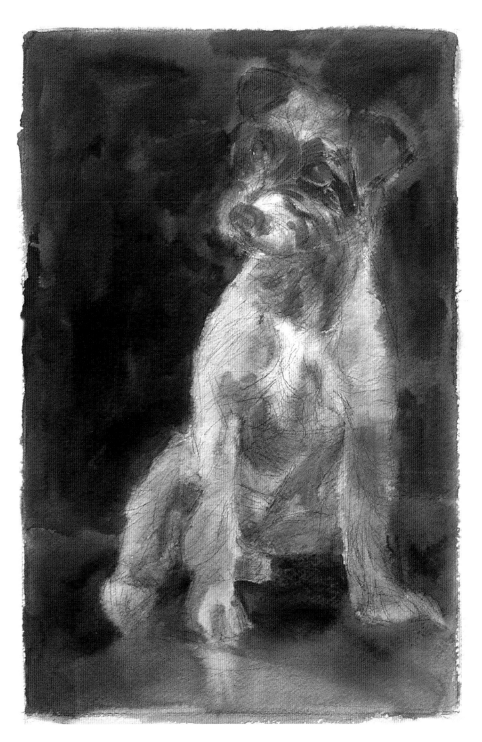

[A] Warm and cool colored grays in this large area of soft background provide interest for the eye.

[B] Strong contrasts of value ensure the maximum amount of light within the composition.

[C] Groundwork of color will excite the eye as lighter, but relatively dull, mixes with white are overlaid.

[D] There is variety in the softness and texture right around the edge. Nature is irregular, often chaotic, so these variations create a more realistic impression of the fur.

[E] Soft darks are the perfect foil for the hard-edged wet-on-dry highlights that are to follow.

[F] Most colors used to this point are some version of a colored gray, be they light or dark. To identify them, try and imagine what is the dominant color and then add it's complementary.

[G] Directional brushstrokes help to indicate the lie of the fur across the shape beneath.

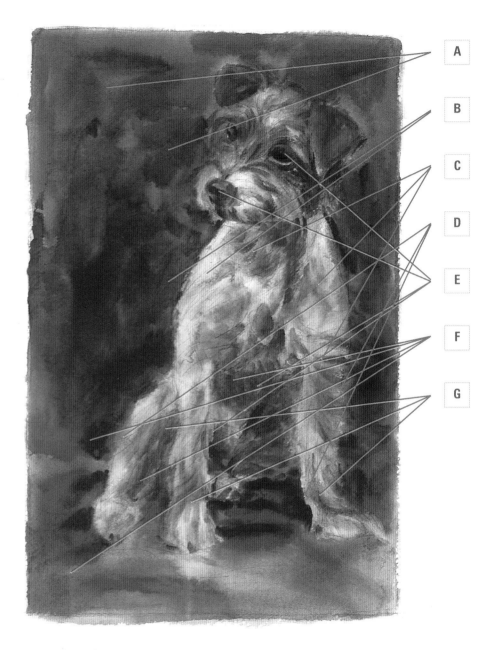

Step 4

FINAL WET-ON-WET LAYER

Detailed wet-on-wet would seem a contradiction in terms, but as the smaller soft accents are revealed, the form does begin to really take shape. These are applied with a smaller round brush onto a surface prewet with the large round brush. Lose edges with this larger brush whenever you stray onto a dry area that results in a hard edge. This detailing can be seen across the features and into the fur. The soft depth of the composition is now fully achieved.

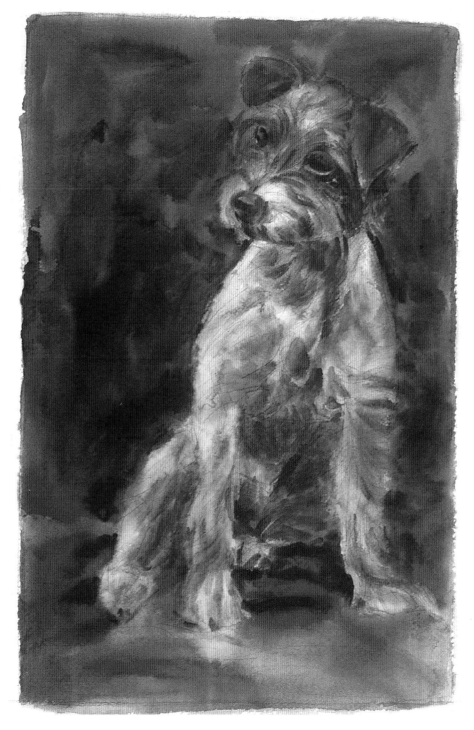

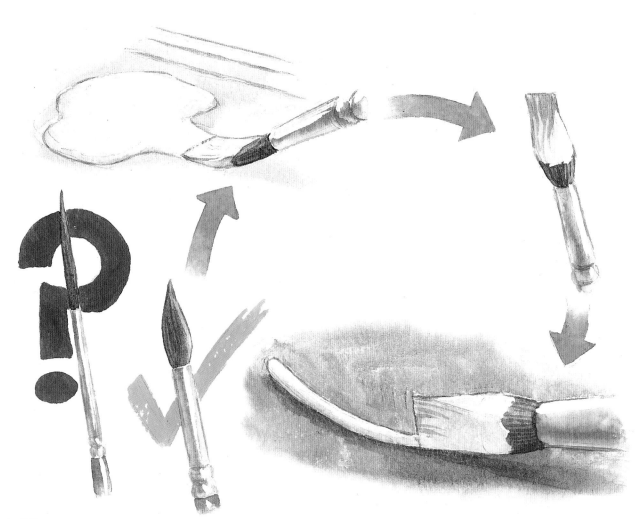

Hints & Tips

LINEWORK WITH A BRUSH

While the Rigger brush can be used for fine linework in acrylic painting, it becomes more problematic when dealing with light line on a dark background. For the color to flow consistently from the Rigger it needs to be fluid. To achieve a fluid mix in painting with acrylics, the answer is to add water; but this dilutes the strength of the color, and the line becomes very weak on drying. The answer is to use a brush with a greater loading capacity, which will deliver a bolder line that is less likely to diminish in power as it dries out. Flatten a medium to small round brush on the palette surface after loading it with paint. Then form it into a chisel point and use it edge-on to draw the line.

Step 5

WET ON DRY

Working onto a dry surface now produces the hard edges that return focus to the composition. The more focus achieved, the more static the image will become, so you must be judicious with this ultimate definition. Use the smaller of the round brushes and flatten it on the palette during color loading. Linework produced with this brush mimics individual hairs on the dog's coat. Note how the strokes are taken beyond the soft edge of the body and limbs, which suggest the depth of the coat. Thus the silhouette is loosened up to become more fur-like. Since the surface is already covered in paint, it is sealed and is, therefore, less absorbent and takes a little longer to dry. Use the end of your finger to smear or tonk some of these fine line strokes so they are partially lifted and blended into the underpainting. Scuffing the color can serve the same purpose, while remaining light and bright. One or two sharp dark accents applied to the nose, eyes, ear — and occasionally to the fur — tighten up each of these areas.

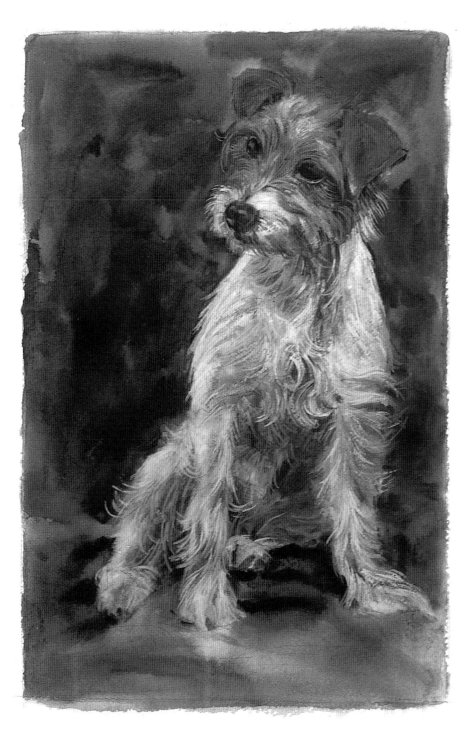

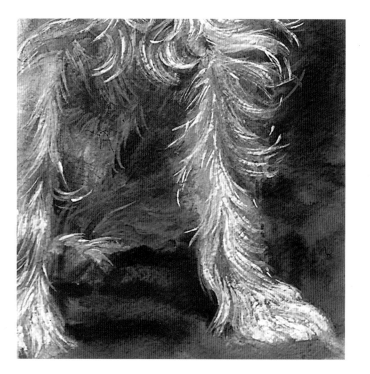

ARTSTRIPS

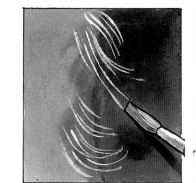

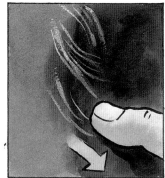

Wet-on-dry highlight strokes can seem to stand proud of the surface.

SMEARING: Pull a finger across or along the wet strokes, or part of them, to lessen this effect.

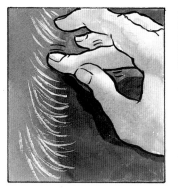

FINGER TONKING: Dab with a clean finger to lift some of the color away from the end of each stroke...

... and allow them to melt in with the rest of the coat.

Step 6

FINISHING TOUCHES: COLORED HIGHLIGHTS

At this stage, the back (center) foot appeared a little dominant. The area was first wetted and then darkened gently to help it recede before concentrating on the final highlights. While one could easily envision that these could be rendered in white alone, there are three reasons why it is best if they are gently colored:

[1] White alone can be a little stark.
[2] Natural white is nearly always a color, yellow in sunlight and blue in shadow.
[3] A color can contrast better with the colors below, thus achieving better definition.

In line with this, apply a blue-white to the white hair over the orange face and a yellow-white down the left hand side of the torso. Rigger brushes are not useful for such fine line work in acrylic. Fluidity is impeded by the fact that they hold little paint, and the stiffer paint simply will not flow. It is better to use the small round brush, flattened on the palette surface into a chisel, to use edge-on. For the final sharp highlights to the eyes, use the very tip of this same brush.

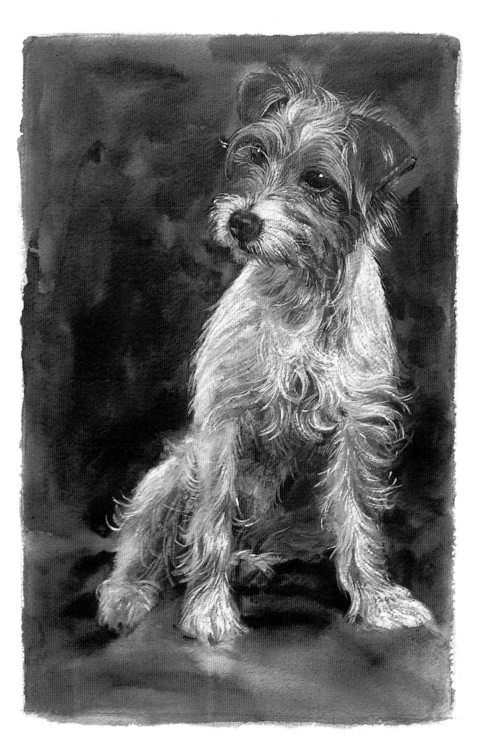

Introduction

Oil painting is one of the most traditional media, and for me it remains one of the most exciting. Yet, for those starting out in painting it can appear to be the sole province of the professional artist, with all its specialized techniques and equipment.

The science of oil painting is quite simple however. When exposed to the air, oil paint reacts chemically to it, and hardens as it does so. Oil is a transparent medium, which when mixed with pigment will allow the color to show through. When the oil becomes hard, the pigment is trapped within it and adheres along with the oil to the surface.

Furthermore, the mixture of oil and pigment can be made more fluid through the addition of either thinners or more oil. The resultant mixes will therefore have either less or more oil than the paint in its original form. As it is the oil that takes a long time to dry, it stands to reason that the less oil in the mix, the faster the paint will dry.

This then is the basis of oil painting in a nutshell. Every method and technique in painting with oils is based around these simple governing facts. Once you know what is happening to the paint layers, the process of laying them becomes obvious.

In this chapter we deal with this process, so that you are equipped with a complete overview of the possibilities inherent in the medium. You will work in a traditional method in which the paint layers are built up, and in so doing you will better understand what function they perform.

The following step-by-step tutorial will not only teach you much about working with oils, it will also teach you much about color mixing and the effects of sunlight.

The method employed is known as working thin to fat, in which the oil in the first layers of paint is reduced. Middle layers require paint used straight from the tube, which have an even oil consistency, followed by the last layer mixes bulked up with oil to create transparent glazes.

This type of layering ensures that the fatter, or more oily layer, is nearest to the surface, where the air can get to the oil and dry it out. To reach lower layers, the air needs more time, but of course they contain less oil. Thus, the layers dry evenly and are less likely to shrink unevenly, which could lead to cracking.

Once this basic concept of oil painting is mastered, you can begin to explore other possibilities, armed with a better understanding of how they differ from the basic approach.

It is possible, for example, to apply an oily wash of color to a surface and then work into this wet-on-wet. Conversely, you can take color straight from the tube and rub it onto the surface to begin a composition. Other colors can then be applied wet-on-wet, but much more stiffly.

These differing approaches are all quite correct and each has advantages and disadvantages over the others.

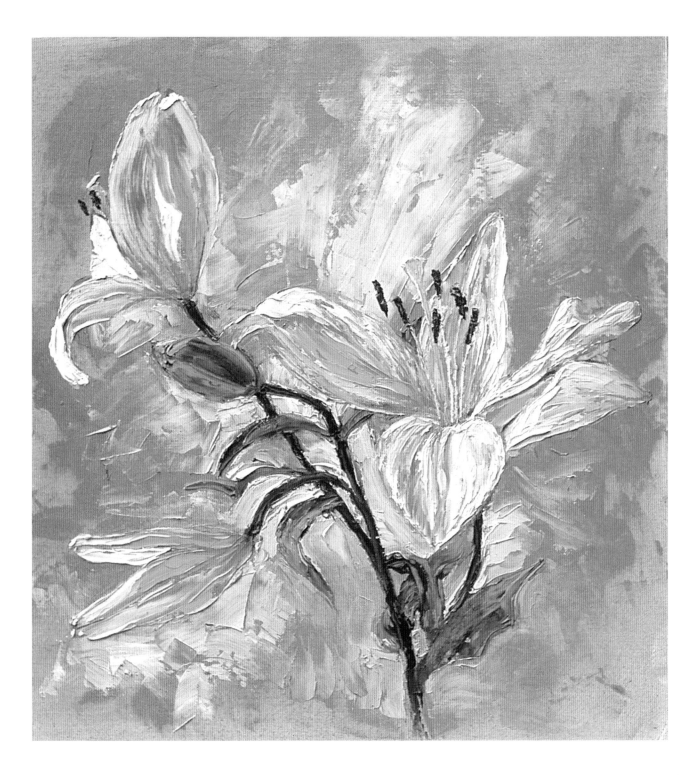

Materials

1. Tube Oil Colors
2. White Oil Paint (Titanium White and Underpainting White)
3. Non-absorbent Palette
4. Dipper for Mediums & Thinners
5. Range of Brushes:
 Filbert, Flat, or Round Bristle for texture; Round Nylon for detail; Nylon Rigger for linework
6. Painting Knife & Palette Knife
7. Stretched Canvas
8. Canvas Board
9. Oil Paper
10. Brush Washer
11. Household Thinner (Turpentine or White Spirit)
12. Linseed Oil*
13. Alkyd Medium*
14. Glazing Medium*
15. Oily Thinner*
16. Artists' Distilled Turpentine*
17. Odorless Thinner*
18. Oil Painting Varnish (Gloss or Matt)
19. Beeswax Varnish
20. Lint Free Rags for Cleaning

*Alternative additives to oil paint, that increase fluidity. Understand function of each before purchasing.

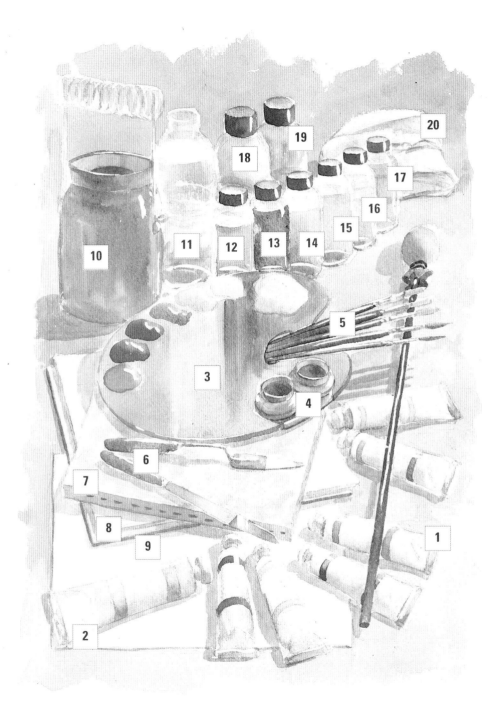

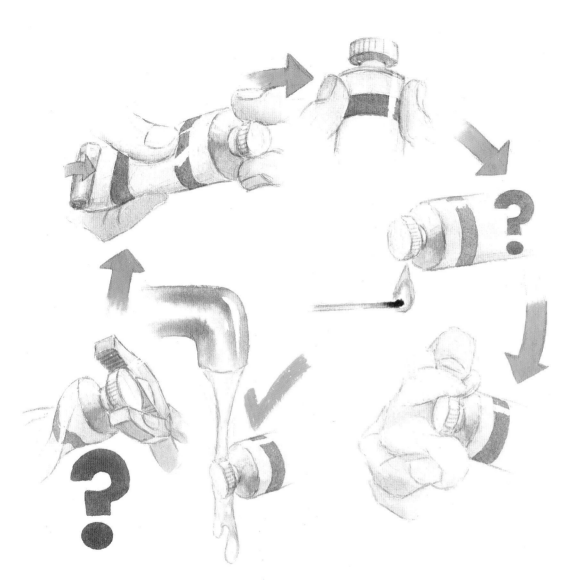

DEALING WITH STUCK TUBE CAPS

A pair of pliers is a valuable addition to your painting kit for loosening tube caps that have dried tightly shut. Unfortunately, if the cap is stuck hard there is a possibility that the tube will twist and tear, allowing the paint out and air in.

Holding the cap under running hot water will expand the plastic of the cap, which should loosen it sufficiently in order that it can be unscrewed. If the cap becomes a little too hot to handle, protect your fingers by wrapping some cloth around it.

Whatever method is used to unscrew the cap, it is imperative that the tube is not twisted and torn apart. Increasing the pressure of the paint in the tube will help prevent this, as the tube is subjected to stress. Roll up the bottom of the tube and squeeze as you unscrew the cap. Then release the roll at the base and gently squeeze the side of the tube to restore its shape and release the pressure.

CAUTIONARY NOTE

You may see some artists warming the cap with a naked flame. Never be tempted to do this, as modern caps are more likely to be plastic, and can melt and burn your hand.

STEP 1: Mix colors stiffly; then add thinner from the side to create a fluid consistency.

Use long, round bristle brush to draw linework efficiently and fill accents accurately.

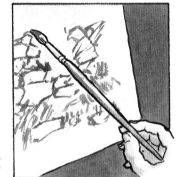

Hold brush as near end as possible to keep drawing relaxed.

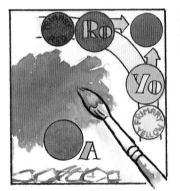

STEP 2: SKY AREA is BRIGHT COMPLEMENTARY to the blue [A] to be overpainted.

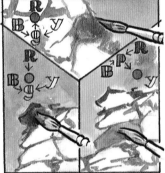

STONES are COLORED GRAYS — a mix of all three primaries with a bias to one.

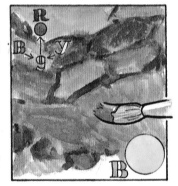

GRASS (dull red) is DULL COMPLEMENTARY to the green [B] to be overpainted.

MATERIALS

Off cut of Canvas Board

Round Bristle Brushes of Various Sizes

Nylon Round Brush

Oil Paints: Six Primary Colors plus Titanium White

Artists' Distilled Turpentine or Odorless Thinner

Oily Thinner

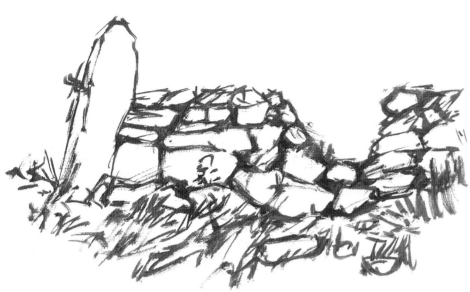

Step 1

DRAWING IN

This much requested subject could form the basis of a painting in its own right. As this is a study, allow the painting to float in the center of the canvas board. This casual approach will allow you more scope to experiment. Keep the drawing as simple as possible so that the blocking in of colors can be approached boldly. You cannot allow yourself to become precious with the drawing at this stage, so be swift and loose. Note how the stones at the base of the wall are the largest in order to stabilize the structure.

Step 2

BLOCKING IN / UNDERPAINTING

Use a larger bristle brush for fast coverage of these underpainting colors. Add plenty of artists' distilled turpentine (thinner) into the paint mix to encourage speed of application and to shorten the drying time of this thin layer. Ensure all of the white within the compositional area is covered with colored grays for the wall; orange as a bright complementary for the sky against which the subsequently applied blue can sing out; and dull red for the grass as a dull complementary for the ensuing greens.

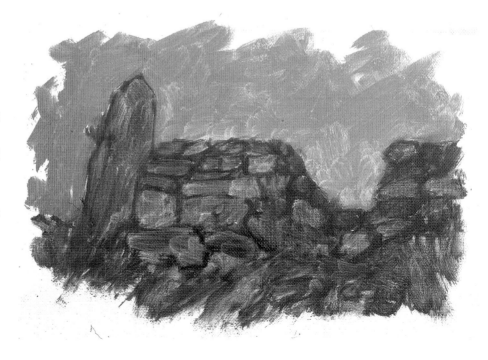

 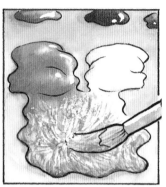 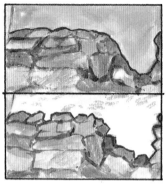

STEP 3: Apply sky color in diagonal bands, progressively adding white.

Don't over mix. Go for streaky color mixes to add character to texture.

Redefine silhouette of wall by painting sky into nooks & crannies = NEGATIVE PAINTING.

Still-wet underpainting will "pull" color from well-loaded brush. Less well loaded and colors will mix.

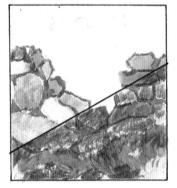

STEP 4: Generally warm colors (bottom) overlay cool underpainting of Step 3 (top).

Overlay these warm colors (top) with gray mixes with cool bias (bottom).

To create muted grays, adjust dull mix on the palette from Step 3.

Dull mixes of orange and warm green provide under painted contrast for cool green to follow.

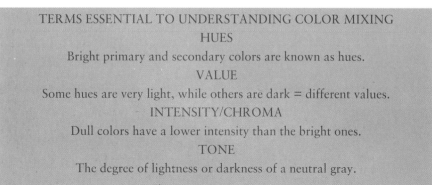

TERMS ESSENTIAL TO UNDERSTANDING COLOR MIXING

HUES

Bright primary and secondary colors are known as hues.

VALUE

Some hues are very light, while others are dark = different values.

INTENSITY/CHROMA

Dull colors have a lower intensity than the bright ones.

TONE

The degree of lightness or darkness of a neutral gray.

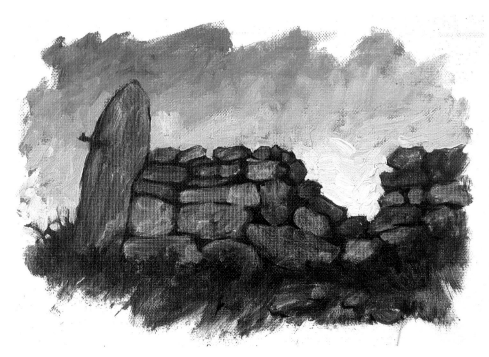

Step 3

Redrawing and reshaping with the point of a bristle brush is usually necessary at this stage; use [Ro+Bp+Bg]. Add just enough thinner to make mix fluid, but not enough to produce "slime". A slightly stiffer mix with more red softens the base of the wall in preparation for some overlay of vegetation. Switch to stiff blue paint (no thinner) for the sky, moving not only toward white in the gap of the wall (see Artstrip), but applying more paint as you go, to build up the texture. Brush marks here are clearly visible, even though they are white. These will take, subsequently applied, transparent colored glazes well, as they run into each groove created by the bristle brush.

Step 4

DARK TO MID VALUES

Continuing the use of stiff (no thinner) color, paint first warm layers over cool underpainting. Then cool colors laid over the warm. These fluctuating color-temperatures afford excitement to otherwise dull grays. The first layer needs to be pushed into the textured canvas surface. However, once this first layer of stiff paint is established, the next layer becomes easier to lay and does not require such pressure. The side of the brush head, gently dragged across the surface, is sufficient to deposit the scuffed color.

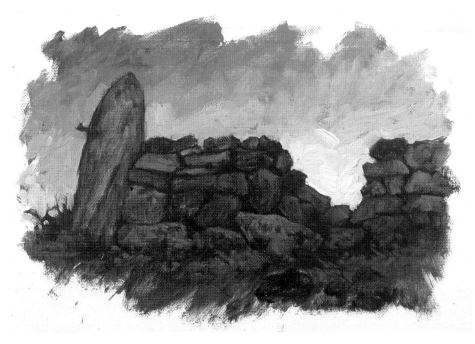

51

ARTSTRIPS

STEP 5: For grass exploit differences in strokes between bristle & nylon brushes. Each provides its own distinctive quality.

Gently "light" shadow side of stones along top edges with reflected blue skylight (Bp+TW)

Regularity in brushstroke will look unnatural.

Keep spaces between leaves and grass (negative space) irregular for more natural look.

STEP 6: Blend sun highlights over rocks [A] and soften some leading edges [B] to suggest bouncing light.

Be selective with final highlights or they may begin to look like snow.

Begin to add yellow (sunlight) into green mix for the grass.

Progressively add more yellow and white. Apply highlights with a round nylon brush.

COLOR MIXING
Where the prefix letter is shown in capitals this denotes a larger quantity of that particular color.
Conversely, where the prefix letter is shown in a lower case, this denotes a smaller quantity of that particular color.
E.G.
Bp= large amount of blue-purple. bp = small amount of blue-purple.

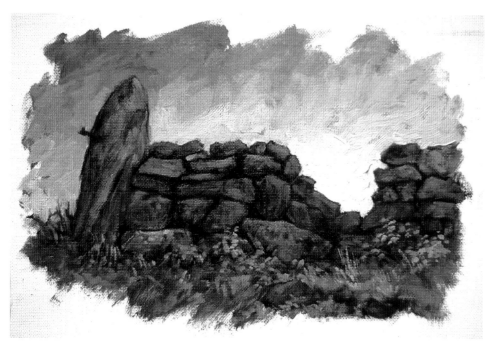

Step 5

REFLECTED LIGHT

The top right hand edges of many of the stones will catch a reflected blue highlight from the blue sky. This color is produced by taking the natural (local) color of the stone and adding blue [Bp] and white [TW]. In the grass this color is applied both with the bristle (broad strokes) and the round nylon (linework and detail). Some areas of grass are highlighted further with more blue [Bp] and white [TW] in the mix. Here, individual blades of grass and small leaves catch these bright highlights, but be vigilant, for it is easy to overburden with detail.

Step 6

DETAIL

Here the sun shines from the left, producing warm yellow lights on the top left hand side of the stones [Yo+ro+bp+TW]. The best contrasts are found against areas of dark rock, which then effects bright shining light. Use all paint direct from the tube with no added thinner. The yellow green mix [Yo+Yg+bg+TW] is first applied broadly with a bristle brush, and as it becomes lighter, is more finely detailed with a nylon brush. When using the softer nylon brush to apply stiff paint, ensure the brush holds sufficient paint inside the head, to hold it in shape.

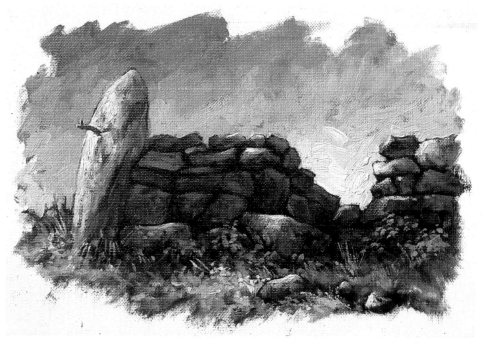

STEP 7: Tints with blue create recession, giving depth to the subject.

Tints with yellow suggest moist atmosphere around highlights.

For tints, mix colors dry on palette before adding medium to edge of mix. This controls quantities.

Tints always look heavy when first applied [top]. With working they become more transparent [bottom].

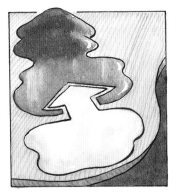

STEP 8: Again introduce medium to edge of tube (stiff) color to control strength and quantity of mix.

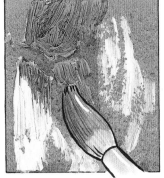

Glazes run into paint textures; are seen more clearly (example shown is too strong so effect can be seen).

Wiping over with finger leaves glaze in valleys, producing stronger contrasts.

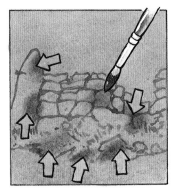

Extra color (no added medium) can be worked into glazes to increase strength.

COLOR REFERENCE
Red-purple (Rp) i.e. Crimson Red
Red-orange (Ro) i.e. Cadmium Red
Blue-purple (Bp) i.e. Ultramarine
Blue-green (Bg) i.e. Prussian Blue
Yellow-orange (Yo) i.e. Cadmium Yellow
Yellow-green (Yg) i.e. Lemon Yellow

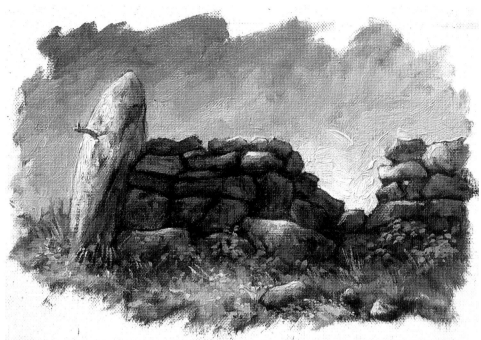

Step 7

TINTS

Basically, tints are glazes with white added and are more or less transparent, depending on the amount or nature of the latter. Zinc white is ideal as it is the most transparent of all available whites. Here they are mixed with an Alkyd medium (glazing medium), applied with a bristle brush and worked gently into the surface. Tints soften detail and allow you to manipulate depth. For the blue tint, Phthalo Blue, a wonderfully intense hue is best, as it holds its strength even when much reduced with white; however, Ultramarine (Bp) will suffice. Either of the two yellows is suitable for the moist atmosphere around highlights.

Step 8

GLAZES

Glazes are simply color thinned to transparency with the addition of a glazing medium. Try using one color only to see the effect on differing colors and textures. Burnt Umber or an equivalent mix [Ro+Yo+bp] will dull the cool (blue) colors, but will also intensify the warm colors (reds, yellows, browns). A glaze will always darken, so be careful not to over use. If you don't like the glaze, you can wash of with turpentine and start again.

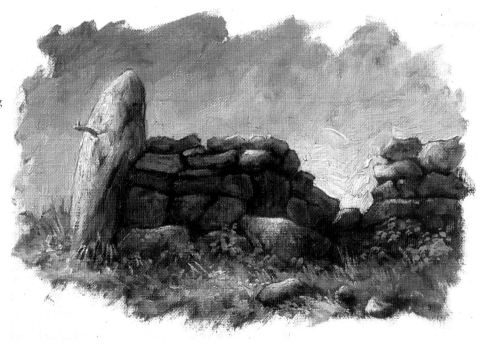

ART STRIPS

STEP 9: Scumble tube color with flat bristle brush. Hold level with surface.

Continue upward, progressively adding more blue and medium to mix.

Once completed place sheet of tissue paper over sky and gently press down (don't move paper)...

...to expose TONKING. Note difference between areas of fluid and stiff paint.

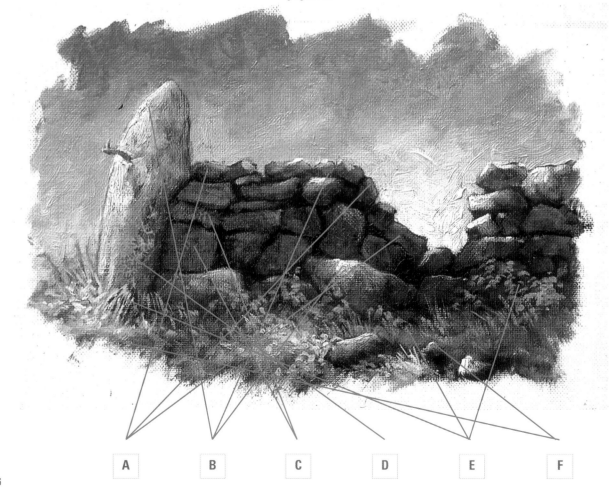

A B C D E F

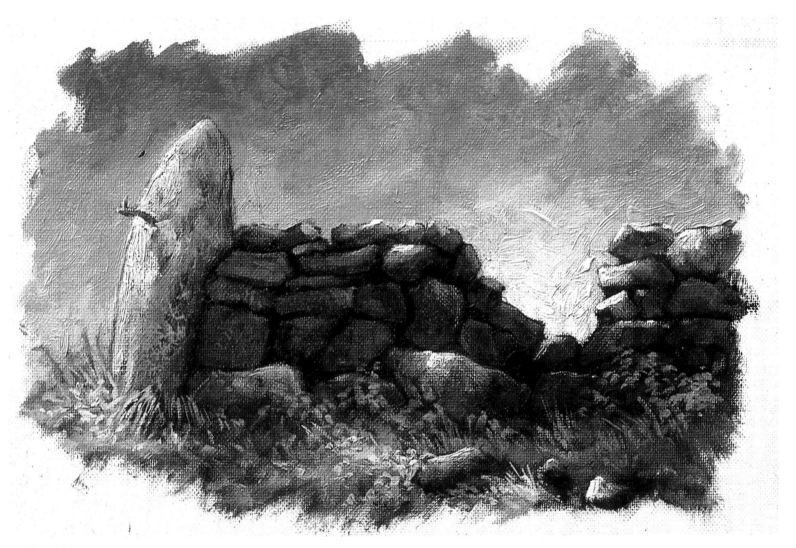

Step 9

SCUMBLES & TONKS

With stiff tube paint, scumble reflected blue highlights [A] and sunlight yellow [B], graduating to white highlights. Tonking can also be exploited to vary the texture on the stones. In the shadows these are dull red and green [C]. The gate stone, however, is a dull yellow and its texture is best observed across the dark area toward the base [D]. To finish off, add a little medium to paint and use round nylon brush to add fine linework for the grass highlights, both reflected [E] light and sunlight [F].

Introduction

The term mixed media covers a multitude of media and techniques, from the combination of ink and watercolor to that of pastel and oil paint. As always, it is essential that whatever media are combined, they are not brought together merely on a whim. The decision should rest on an understanding of the strengths and weaknesses of each medium in question and these properties being combined to enhance their inherent potential.

Acrylics and soft pastels are used together in this step-by-step tutorial to bring out the specific qualities of each medium. The acrylic underpainting provides strong, bright colors and texture. Acrylics on their own can sometimes be a little over bright or bland, and the finish can seem a little sharp.

In this composition the pastel layer provides the softness and seeks out the textures of the acrylic impasto surface. Once we begin to remove the pastel applied over the acrylic, we rediscover the acrylic detail and can then choose which areas to reveal and which to keep soft.

By the time you have reached the pastel lift-off stage, you will instinctively know which areas of the image are most important and will then be able to control the focus of the painting, to express this definition, exactly where it is required. The result is of interest, as the overall effect is one of a low-key painting. This is where the values throughout are all kept relatively dark, and the image relies on intensity of color and texture for visual definition and focus.

The best figure studies are often those that are not planned. This was certainly the case here when a foal, only a few days old, wanted to show her playfulness and affection. Luckily, a camera was on hand to catch the moment, which — by nature — was fleeting.

Effectively, both the foal and the girl block the light, producing a subject that is backlit, and although unusual, this produces a stunning effect. Small areas that do receive full light, such as one of the foal's ears, the girls wayward hair, and her fingers, stand out against the dark values elsewhere.

By squinting your eyes, you can see the effects of this immediately. While the subject is full of color and texture, the majority of the surface is cast into shadow.

Such an image, wrought mainly in dark values, is a good example of the use of "low key" tonal balance.

Shadows are naturally soft as well as dark, but can still carry intense color. The choice of media for this composition is dictated by the need to match these qualities. The use of acrylic paint provides the color, while pastel is employed to blur, darken, and create soft texture.

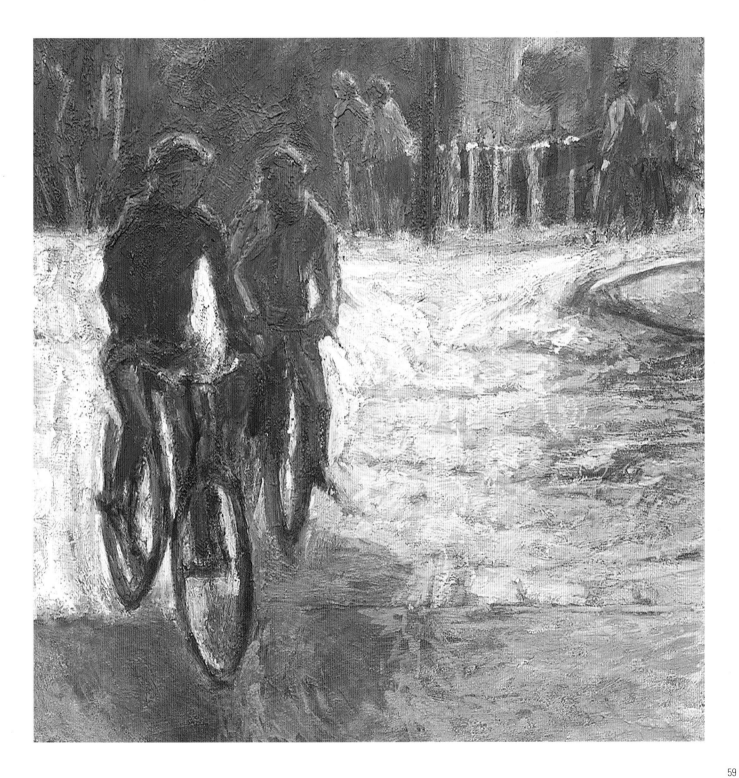

Materials

1. Raw Umber Soft Pastel (or other brown)
2. Kneadable Putty Eraser
3. Compressed Paper Wiper
4. Modelling/Texture Paste (Acrylic)
5. Screw Top Mini Pot (for preserving small quantity of texture paste)
6. White Acrylic Paint
7. Acrylic Paints in Tubes
8. 0.5mm Automatic Pencil 2B Lead
9. Watercolor Paper
10. Drawing Board (for stretching paper)
11. Gum Strip (for stretching paper)
12. Stay-Wet Palette
13. Plastic Paint Wells with Lids
14. Water Jars
15. Painting Knife
16. Deposit of Texture Paste
17. Deposit of White Acrylic Paint

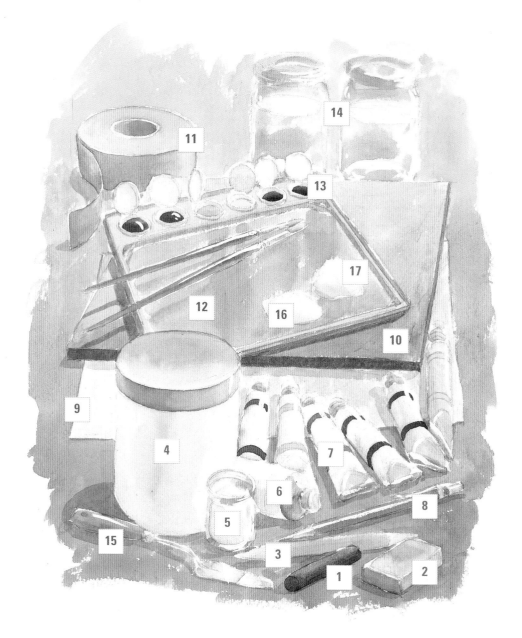

Making Fluid Acrylic Mixes

ADDING WATER

Acrylic paints can be let down simply by adding water until they reach the consistency of watercolors. At this fluidity they will naturally run if applied heavily to an upright surface. The acrylic medium or glue inside the paint is so strong that even when turned into such a thin solution it is still quite permanent, holding the pigment efficiently to the paper. However, the color will lose its gloss and thus some of its visual depth.

ADDING ACRYLIC MEDIUM

Acrylic medium, in raw form, can be added to the color, making it more transparent without losing its viscosity. The gloss may be increased with the addition of a gloss medium, or conversely it can be reduced with a matt medium. The tactile strength of the paint is vastly increased with the addition of acrylic medium, as it is equivalent to adding more glue. Its strength is such that materials such as paper, leaves, fabric, etc. may be embedded into the paint, which when dry, will hold them firm.

ADDING GEL MEDIUM

Gel medium is much stiffer and as such is excellent for adding to color, when working upright, as it is unlikely to flow. With such stiff glue, using heavier materials to produce collages becomes possible.

CAUTION
Take care not to leave medium in your brush. It is difficult to see in your brush and could easily be missed. Ensure you clean all brushes thoroughly; otherwise, the medium will set rock hard and the brushes will be lost.

Hints & Tips

SIMPLIFYING COMPLEX SHAPES

MASSING SHAPES: Whatever the subject or its complexity, you can break it down mentally into simple shapes. My preference is for shapes that have straight edges, others prefer curves. It really does not matter, as long as it works for you and allows you to look beyond the object to see the proportions of its masses. Do not forget that the negative shape of the background is every bit as important as all the others in making up the balance of the composition.

LINKING SHAPES: Trying to keep proportions and relationships correct across the entire surface can be frustrating. However, as the shapes of the drawing emerge, you can use either drawn or imagined lines to link them together. These lines, parallel to the edge of the rectangle, will tell you what should be kept in line with what. Hold a pencil in front of the subject to visualize these lines and note also how they cut through shapes. For example, as these lines move through a head, hand, or arm, do they cut it in half? What are the proportions?

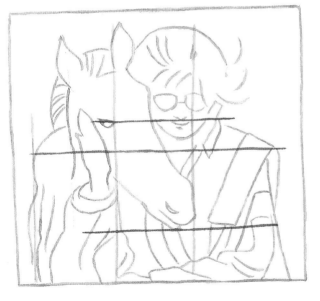

MATERIALS
Rough Watercolor Paper • Acrylic Paints in Tubes: 6 Primary Colors plus Titanium White
Nylon "Bristle" Round Brushes: Medium and Large • Stay-Wet Palette • Pencils • Kneadable Putty Eraser • Acrylic Matt Medium
Acrylic Gel Medium • Modelling/Texture Paste • Paper Wiper (Stub) •Artists' Quality Soft Pastel

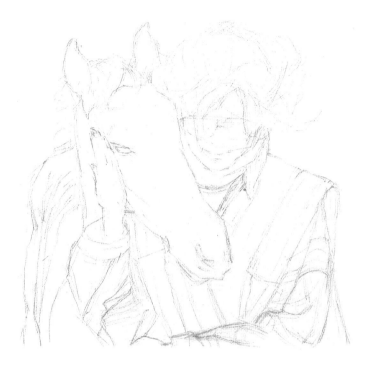

Step 1

Stretch a sheet of watercolor paper and when dry, draw in the main shapes. You can be as heavy as you want with this drawing, for it will be covered completely by the opaque acrylic and pastels. Here the drawing is worked in pencil, but you could complete it in anything from charcoal to felt tip pen. Look carefully at the abstract shapes of the composition to get the proportions correct. There is foreshortening in the girl's face as she looks down and similarly along the foal's body. The latter is a narrow rectangle. Use the simple method of checking that horizontal, vertical, and diagonals are in proper relation to each other. For example a horizontal, line through the foal's eye touches the bottom of the girl's nose. A plumb-line vertical from the same point travels down the inside of her arm.

Step 2

BLOCKING IN: WET ON DRY

Build the acrylic layers from dark to light, working with the darkest colors you can manage. These are the accent colors, so don't worry about these being right; just make them dark and slightly varied in hue to achieve the definition of masses required. Use a large brush, work swiftly and be as relaxed as you can. You do not see the composition's true colors or shapes until all the white is covered. At this stage you are still drawing in the composition, in that you are discovering its qualities. When blocking in the background, you will appreciate the negative spaces and how they help to define the silhouette of the foal and girl. Apply directional strokes of color across the girl's hair and coat to get the feel for the lie of the hair and the fabric.

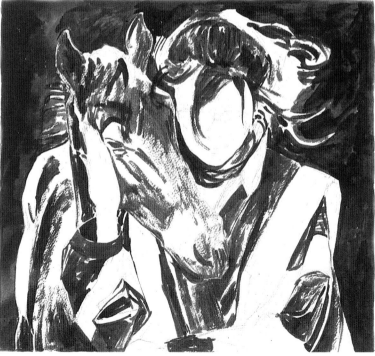

63

Step 3

BLOCKING IN

Continue to cover the white paper. When white is used in mixes, it is used to dull color and make it more opaque, rather than very light. As the last bit of paper disappears, the applied colors begin to work against one another. Compare the colors in this stage to how they looked in the previous step. Often at this stage you will find that a color you thought was almost black will in fact not be dark enough. Without the darks created here, the lighter colors that are to come will have nothing to be seen against, so the bolder you are now the brighter the finished results.

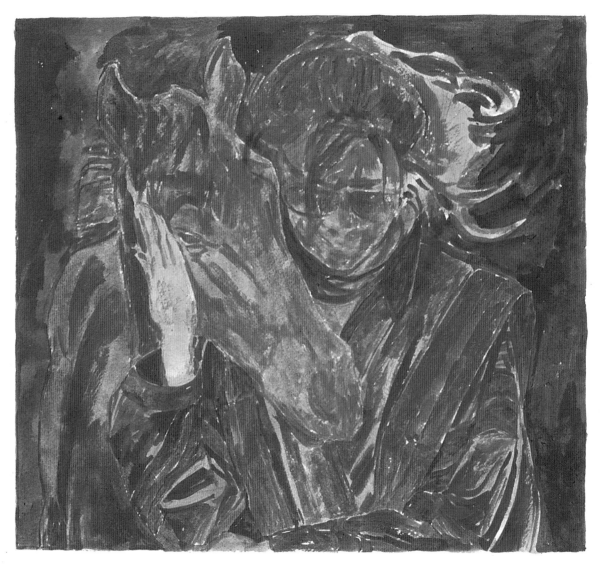

Step 4

REFINING THE COMPOSITION

Having completed the blocking in, you can take the time to correct any inaccuracies in the composition. I identified that the angle of the girl's head was wrong; it wasn't angled sufficiently. Large changes such as this can be made at this stage without hesitation. Later, when you have applied detail, they will be less easy to correct. You will also see redrawing around the foal's ears, easily achieved with a darker acrylic line. These changes may seem small, but they can make the difference between something you are happy with and something that ultimately offends. So get them right now.

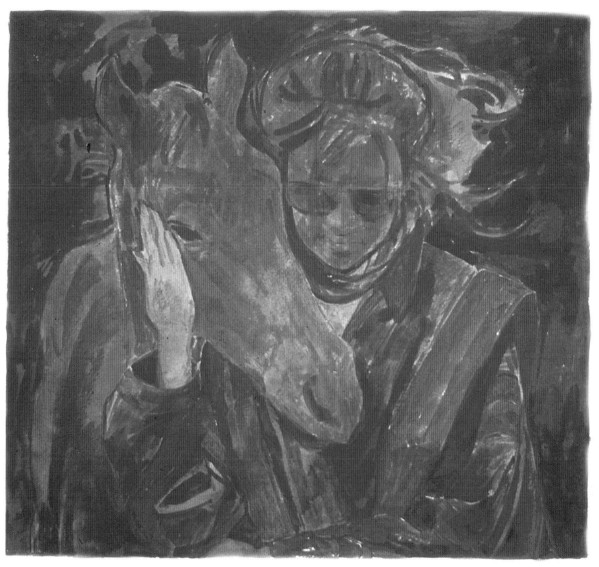

Hints & Tips

Using stiff heavy paint mixes, especially those containing modelling paste, demands a degree of brush control so that the applied textures will be structured to the subject. Soft brushes whose heads are flexible will tend to bulk out or misshape as they take on the heavy load. The general rule that will help you is this: match the brush to the mix. In other words, the stiffer the mix, the stiffer the brush should be to match it. Stick to this formula and the paint will be delivered with ease to the surface of the painting.

A R T S T R I P S

IMPASTO: Layers of color with modelling paste (right) capture light more effectively than layers of paint alone (left).

Try following mix to identify differences between using modelling paste or white in a color mix. Paste + color (left). White + color (right).

On mixing, white pigment changes value dramatically (right)....whereas texture paste increases bulk (left).

Dry paint surface structurally enhanced by modelling paste. Thus provides effective tooth for pastel application.

[A] Color layered from dark to light.

[B] Do not worry about hard-edged paintwork. The pastel layer will soften these. Concentrate on developing contrasts of value....

[C] ...and texture, which is aided by the generous use of modelling/texture paste.

[D] The developing layers of lighter values are cool (added blue-purple) in the shadows, suggesting reflected/cool light.

[E] For sunlight — either falling directly on or through surfaces — the lighter values are warm (added yellow-orange).

[F] Medium Sized, round brushes are used for the bold strokes.

[G] A fine Rigger brush can be used for fine line and highlight detail.

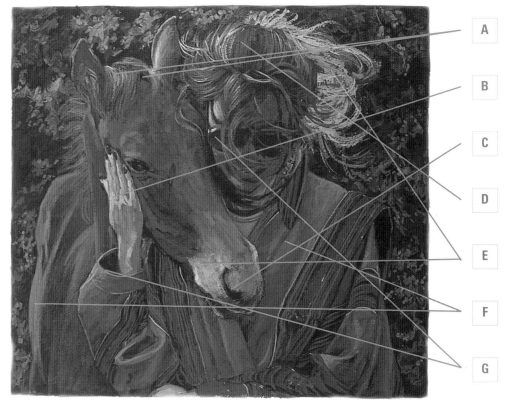

A

B

C

D

E

F

G

Step 5

Build layers of color, progressively lightening the values and adding modelling paste to the mix to develop texture. This texture is both visual and physical, and the impasto highlights catch the light that falls across the surface. This impasto brushwork will be receptive to the pastel, giving it a firm surface on which to adhere, and will be revealed as the pastel seeks out its corrugations. Adding modelling paste, rather than too much white, is also an advantage in that the lighter values are reached more gradually. While the aim is to eventually go very light in the bright areas, there is a danger that if they are produced too swiftly, the middle values may be missed.

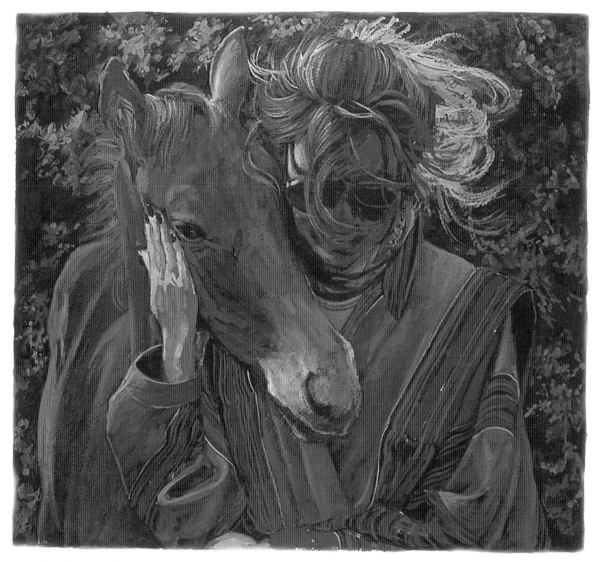

Values and texture will then be underplayed and be less dramatic at the pastel stage. Have patience, build the layers gradually, and keep in mind that acrylic color always dries darker, so the highlights will really need heavy attention.

Hints & Tips

One beneficial side effect of applying the pastel layer is its calming and unifying influence on the acrylic layer. Acrylic tube color is notoriously bright, even when mixed with white and modelling paste (Diagram 1). Certainly, if too many of these bright colors are placed close together in the composition, the result can be rather dazzling. Once covered in a thin layer of a single pastel color (Burnt Umber in Diagram 2), both the color and values of the acrylics are unified to some degree. A kneadable putty eraser lifts pastel from the prominent textures, leaving the pastel pigment in the valleys in between these textures.

NOTE: Although modelling paste was used in the paint mix, the most dominant texture is the surface of the watercolor paper itself, and it is this surface that is identified by the pastel. To overcome this, further layers of impasto would need to be added.

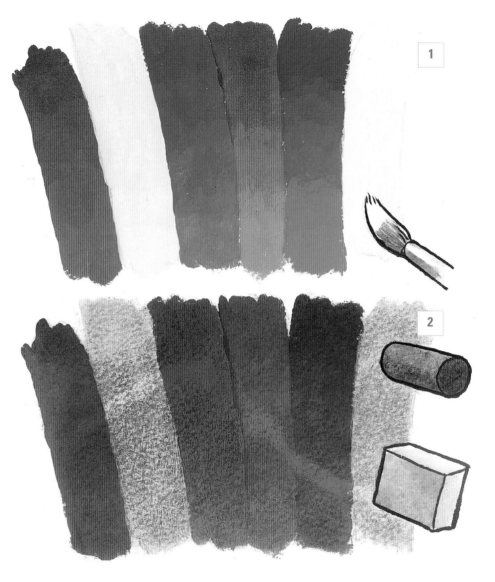

1

2

Step 6

This stage can be quite frightening when attempted for the first time. It is, however, a means to an end, and eventually you will come to enjoy blocking on the pastel. Since the application is to be heavy, it is inevitably quite messy. Should you wish to keep the edges of the painting clean, these will need to be protected with masking tape. Reduce the adhesive properties of the tape by first sticking it to your clothing, as you do not wish to tear the paper when removing it later on. Use a dull dark color such as the Raw Umber used in this tutorial. Once covered, use a compressed paper wiper to work the pastel into the impasto textures of the acrylic. A compressed paper wiper will not shred on the hard textured surface. Use the side of its head and turn frequently to prevent the point from being lost.

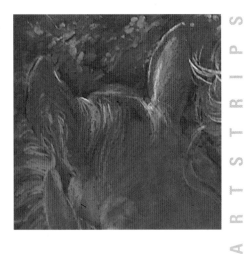

ARTSTRIPS

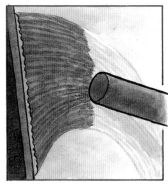

THE TECHNIQUE IN CLOSE-UP: Each impasto brushstroke has a series of grooves or valleys, created by the brush fibers running along its length.

Once dry, these are filled with soft pastel.

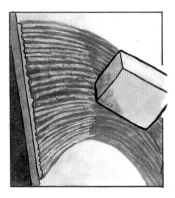

Erasing lifts pastel from the raised texture surface, leaving valleys filled with dry pigment

Gentle sanding dislodges more surface pigment, enhancing the previous effect.

Step 7

Now the physical structure of the surface comes into its own as you work back down through the pastel to rediscover the colors and textures. Use a kneadable putty eraser to begin gentle erasing. You can see where most of the image lies beneath the pastel and can thus decide which areas are of most importance to be restored to view. Other areas can be left soft and unfocussed. Bright, detailed highlights should receive the most attention from the eraser in order to bring them back into sharp focus. Gradually, the image is restored or rediscovered. Do not work on just one area; work swiftly across the composition allowing the entire image to develop, much as a Polaroid photograph does. The areas left soft and dull play just as important a role as those that are sharp and bright.

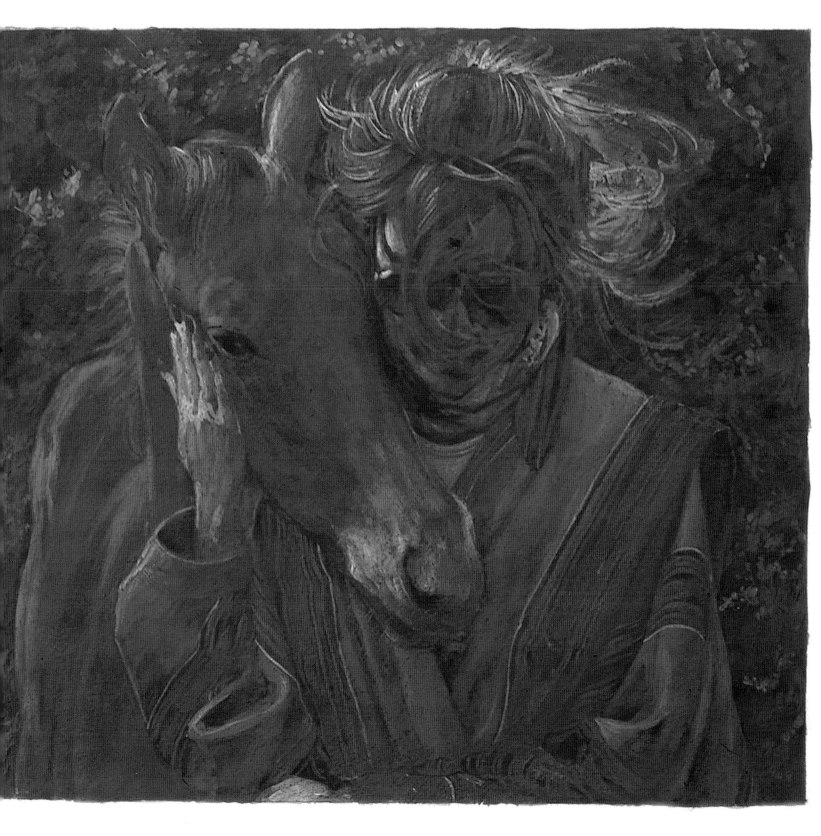

Introduction

For many, watercolor pencils prove invaluable as the stepping-stones that take them from drawing into painting. The possibility of marks drawn with a colored pencil being subsequently transformed into paint will always retain its magic.

However, just as drawing with a pencil is time consuming, so too is working with watercolor pencils. The logical step forward is to use a thicker lead. While these are available, there is an alternative that offers even wider scope in the form of larger, thicker sticks of color known as watercolor sticks, pastels, or crayons. These can be boldly and swiftly applied, producing a solid mass of pigment with the minimum of effort, thus giving you greater freedom to be much more expressive.

The benefits offered by this medium as an extension to drawing, either for the beginner or the more advanced artist, are immediately obvious. Outdoor sketching in color is readily achieved with the minimum of materials. Slipped into a pocket or small bag, a box of colors, a brush, and some paper will give hours of pleasure with very little worry. Full-size paintings can be worked up and completed on the spot or sketched dry in the field, to be finished off later in the studio with the addition of water.

A limited box of colors can be an advantage, for you are more likely to produce images that are harmonious in their color balance. Spontaneity will be the key to a successful painting, for you will have at your fingertips a means to create washes or textures with the minimum of fuss.

The crayons tend not to be as heavily pigmented as watercolor pencils, which allows you to work a little more aggressively with them. This reduced pigmentation also keeps their price down.

Keeping the points sharpened with a standard pencil sharpener allows the use of hatching and cross-hatching and a smooth shank for shading. Any loose particles of pigment that are sharpened off do not need to be wasted. These crumbs can be dropped into a wetted area on the painting surface to yield interesting textures and effects.

Rather than simply work in one layer, the nature of these crayons enables you to build up layers of color, which can be applied dry and then finally wetted with a soft brush to blend them together. Alternatively, wet each layer successively as they are applied, or for another approach entirely, wet the whole surface before applying the layers.

Blending is achieved by using a soft, wet brush while the colors are still wet, and erasing, by lifting off with a brush. Techniques identical to those used in watercolor painting. Spraying or splashing water onto the surface is another method that can be used to wet the pigment, allowing it to spread naturally.

The versatility of this medium is demonstrated by the fact that it can be combined with watercolor pencils, watercolors, or acrylics for an abundance of differing effects.

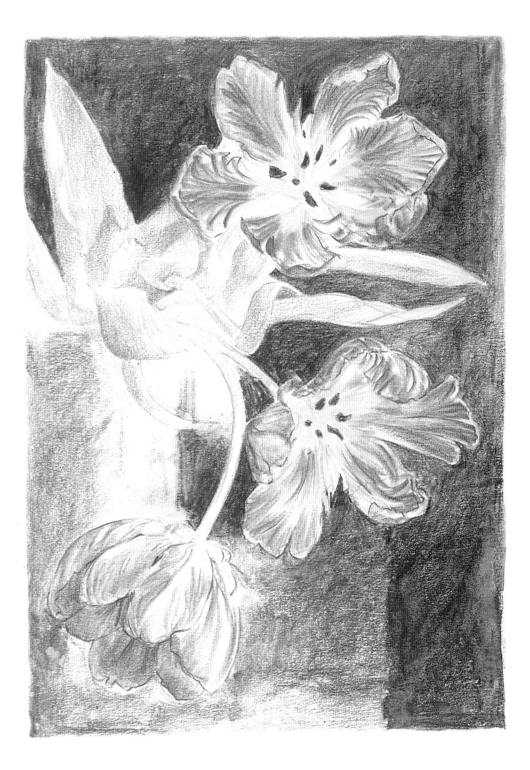

Materials

1. Boxed Set of Woodless Watercolor Sticks/Pastels/Crayons
2. Round Water color Brush (for spreading & blending)
3. Flat Nylon Brush (for lift-off)
4. Compressed Paper Wiper (for dry spreading & blending)
5. Bristle Brush (for wet lifting, spraying, spreading, & blending)
6. Pencil Sharpener
7. Kneadable Putty Eraser
8. Sharp Knife (craft or scalpel)
9. Plant Mister (for dissolving surface pigment)
10. Water Supply
11. Old Toothbrush (spraying)
12. Absorbent Paper Towel
13. Watercolor Paper (Hot pressed or NOT)

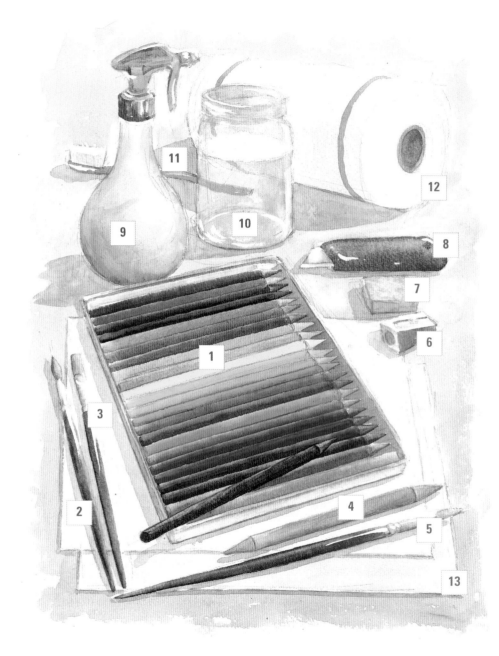

Working With Watercolor Crayons

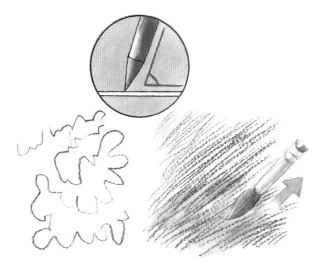

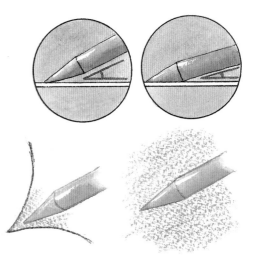

Watercolor sticks/crayons are quite versatile. Use the point at a steep angle to the paper to achieve descriptive linework. Vary pressure to change power of hatching, and then soften with a damp soft brush, pulling the stroke in the direction of the hatch.

Use the shank rather than the point and hold the stick at a lower angle to work into awkward corners. For swift coverage, flatten the angle even more so that the whole shank is presented to the surface. This works both on wet and dry surfaces.

Blending can be achieved by overlaying color, but when colors are laid side by side, you may wish to move or blend them into one another. Using a paper wiper in this instance yields dubious results, although some color movement is possible. A wet brush works dramatically better.

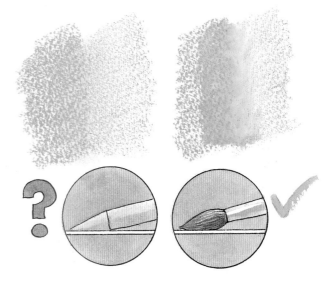

Hints & Tips

NEGATIVE SPACE

Often the simplest of subjects can be the most dramatic. A single flower laid on a plain background may well be more spectacular than a landscape crammed with detail. The secret of success is to balance the positive object with the space around it and the shapes that these create with the perimeter of the composition. This is known as the negative space of an object.

When judging the space, try to ignore all detail and concentrate on the silhouette. Imagine you are looking down on the map of an island in the sea. Does the island have lots of interesting bays and inlets to capture your eye? What jigsaw shapes do these make in relationship to the edge of the rectangle that contains the map and how irregular are they? The more irregular the shapes, the more captivating the composition will be.

A useful way of approaching a plant or flower study is to draw only the negative shapes. This will make you more aware of exploiting them in the future, and once you begin to use negative shapes, they will help enormously in the drawing of positive objects.

Look at the bottom right-hand corner of the diagram. I did not notice the solid black rectangle that had developed, and it was to cause problems later on in the step-by-step tutorial that follows, in which I demonstrate how this problem was overcome.

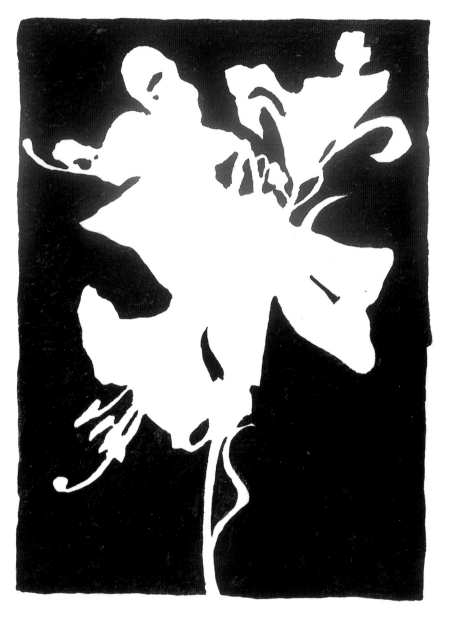

MATERIALS

Stretched Sheet of Hot Pressed or NOT Watercolor Paper

Boxed Set Woodless Watercolor Sticks/Crayons

2" (50mm) Hake Brush

Step 1

Stretch a sheet of watercolor paper and when dry, sketch out the dimensions of the central motif in a very light yellow (Raw Sienna). This should be so gentle that while delineating the subject, it will easily be incorporated into the overall color. Use a blue (Indigo) to roughly block in the negative spaces of the background. The general balance of the composition is now established.

Step 2

Use a dampened large round brush to wipe over and dissolve the pigment, which will allow you to experience the intensity and spread of the pigment. Use the side of the brush head to reduce friction and spread color gently. Wet one color at a time, cleaning brush between colors to avoid unnecessary color mixing. When dry, add a gentle light blue for shadows on the white petals, a Zinc yellow for the stamen and petal bases, and a mid yellow for the stamens. At this stage all forms should still look abstract, due to their lack of detail.

Hints & Tips

WORKING WET ON WET

When working into a wet surface, the stick/crayon dissolves swiftly. Delivery of such an abundance of pigment will soon blunt the point unless the stick is constantly rotated during application. Keep rotating while working to retain the point with which to work into tight corners and for detail.

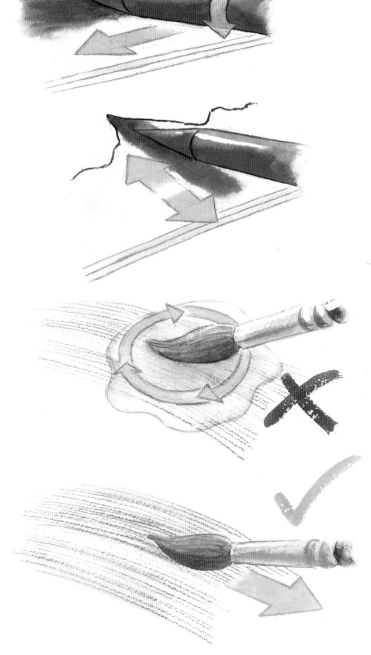

REWETTING & BLENDING FINE LINE HATCHING

When blending hatched colors together, it is easy to overwork and lose the distinguishing features of the linework. Overwetting and overworking should be avoided. Instead, go with the flow by wetting only gently, drawing the brush in the direction of the line hatching and using the minimum of brush strokes. The lines are retained while filling the spaces between with gentle colors.

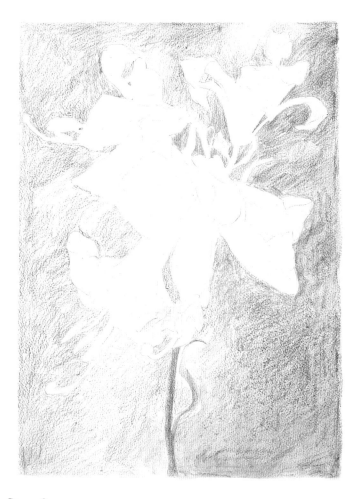

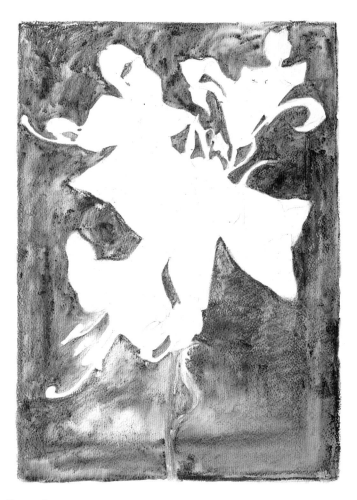

Step 3

Dissolve previously laid colors starting with the warmest (yellow) and then working to the coolest (blues), being vigilant to keep the brush clean of color mixes. Once dry, use a blue (Indigo) to judiciously draw descriptive lines around the flower edges. Use Burnt Umber to block in negative spaces immediately around the flower heads, moving to a green on the right hand side and stem.

Step 4

Wet the background in sections using the Hake brush for large expanses and the point of a round brush to work into corners. Draw into the wet sections using a dark blue (Indigo). For more dramatic impact, you might try dipping the crayon into the water jar before applying. The powerful deposits created can be moved with the round brush and even more water applied, while the surface is still wet. You will find the pigment to be heavy, tending to cling to the surface. Do not attempt to wipe off color with a fingertip, as this only impacts the pigment into the surface. Use an absorbent tissue instead.

Step 5

Use the crayon tips to work up line shading to further shape the petals. Bear in mind, however, that the contrast achieved already with the background is to be retained as much as possible. These directional lines should travel along the petals, describing their form and imbuing them with hints of color.

Petals:	Raw Sienna
Stamens.:	Middle Chrome and Zinc Yellow
Petal Bases:	Zinc Yellow
Stems and Pistols:	May Green
Petal Shadows:	Ultramarine and Dark Violet (being opposite/ complementary to the yellows and oranges to suggest sunlight)
Stem:	Indigo
Leaves:	Burnt Umber and Venetian Red

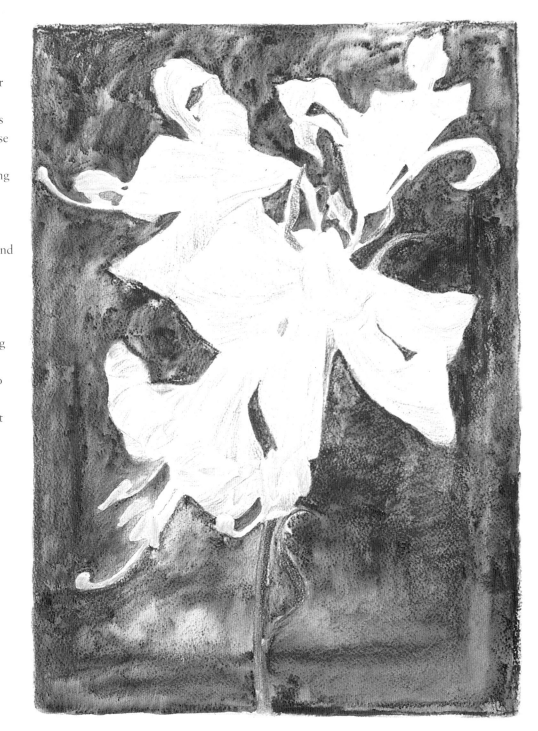

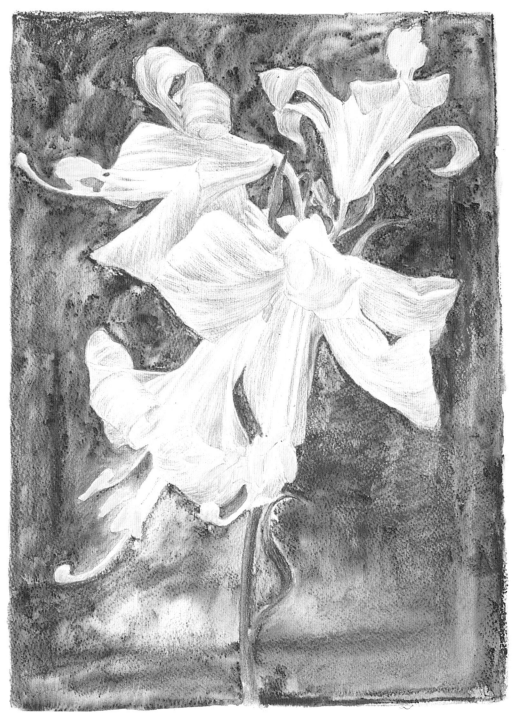

Step 6

Stroke along the length of the petals with a wet brush. Do not overwork; use one stroke only to retain character of the drawing. Allow to dry, and then soften all the petal colors and the edges by overdrawing with pure white. This is used not to lighten the colors but rather to subtly blend and reduce their intensity. The white crayon smoothes the surface so that it can now accept fine black hatching, which further dulls the colors and adds soft values. Certain petal edges are accented with the black, using a fine descriptive line.

[A] The inner rectangle that saved the day in balancing the composition by relieving the solidity of the bottom right hand corner.

[B] Strong tonal and textural contrasts allow the flower to appear white, despite its gentle coloration.

[C] Strokes applied wet-on-wet are wonderfully solid and the pigment really grips the surface.

[D] Scuffing over the wet-on-wet strokes once dry allows the paper texture to play its role.

[E] The drama of the composition is the contrast between petal and ground, but the petals themselves are gently colored with directional hatching of lines, a mesh that follows the contours of the flower.

[F] Bright complementary contrasts. These accents of color excite the dominant blues throughout the composition. Place your fingertip over these accents to see how the picture suffers at their loss.

[G] When wetting and softening fine linework, ensure that you are not dissolving them entirely, or you will lose the directional flow of the surface.

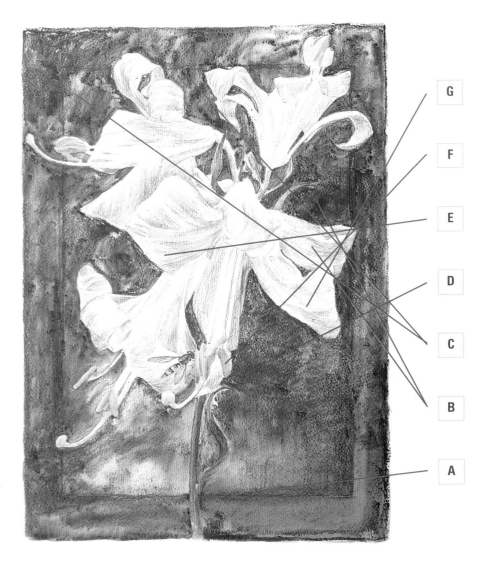

G

F

E

D

C

B

A

Step 7

Occasionally, in spite of the best of one's intentions, a composition can become unbalanced. In this tutorial, the balance of the background color has made the negative shape in the bottom righthand corner too powerful. My solution was to cut through the shape, in this case with a second inner rectangle following the outer rectangle of the picture's edge. This tightened up the balance considerably and helped to hold the irregular shape of the flower in place. Final touches were made to the stamens with touches of red (Crimson Lake) and to the silhouette of the pistols (Indigo descriptive line). Detail to the hover fly is fun and provides a little focal point to discover as the viewer explores the flowers.

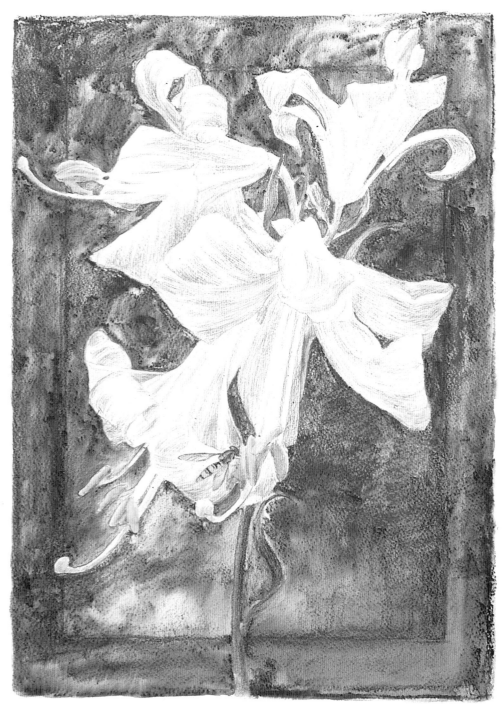

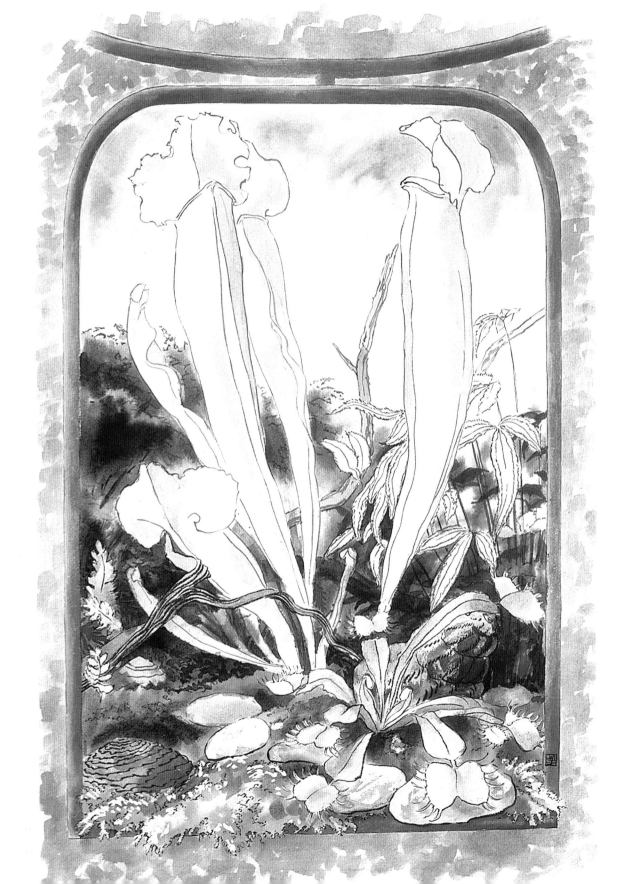

INKS

Introduction

The far eastern saying "in ink are all colors" succinctly puts over the fact that an extreme range of values is achievable, even when working with merely one color. Ink has a long history in the Orient, where it still is used not only for producing images but also in working on incredibly fluid calligraphy, which is an art form in its own right.

Ink is available these days in a multitude of forms, from felt tip pens and ballpoint pens to the familiar ink used with drawing and writing tools such as quill pens. A versatile medium, it is adapted into various forms, each specially developed to work with a panoply of tools. While innovative forms are constantly put on the market, those used by artists can be placed within three principal categories.

WATERPROOF INKS cannot be re-dissolved once dried on the surface. These are created by mixing soluble dyes in a shellac base, a type of varnish that dries to a hard, glossy finish. This quality is naturally imparted to the waterproof inks, imbuing them with a richness and depth that is a joy to use.

When using waterproof ink, great care must be taken of the instrument used in its application. Once the shellac has dried, it can clog or damage drawing and brush heads. It is, therefore, absolutely crucial that these tools are washed out immediately after use.

NON-WATERPROOF INKS do not contain shellac; they are thus not glossy and can be re-dissolved after drying. This removal enables color to flow and the correction of mistakes on less absorbent papers. Traditional Chinese inks fall into this category.

LIQUID ACRYLIC INKS share the permanency of shellac based inks; however, being acrylic based, these inks cannot be mixed with traditional waterproof inks. Caution and care has to be exercised when working with these swift drying permanent inks.

All inks, being created from soluble dyes, tend to stain rather than cover the absorbent surface onto which they are applied. This invasion of the surface causes the color to dry along its edges much more swiftly than when using pigment-based media. This must be taken into account, especially where soft-edged qualities are required. However, most watercolor techniques, such as Wet on Wet, can be harnessed for use with ink.

Colored dyes, especially when let down into thinner solutions, tend to fade in bright light conditions. This fugitive nature of inks needs to be taken into account when

producing work for hanging on display. Acrylic inks are a little less fugitive but can still suffer when used in weak solution and displayed in strong light.

Having taken these characteristics into account, working with inks is to work with a medium whose colors are succulent, which are easily applied to different effect when used with a multitude of tools, can be readily obtained, and are relatively inexpensive.

Materials

1. Waterproof Inks
2. Non-Waterproof Inks
3. Acrylic Inks
4. Ceramic Mixing Palette (ink stains plastic)
5. Water Jars
6. Supply of Distilled Water (applies mainly to hard water areas)
7. Absorbent Paper Towel
8. Paper: smooth, thick, and well-sized is best
9. Hake Brush
10. Round Brush
11. Rigger Brush
12. Brush Pen (with nylon filament brush head)
13. Bamboo Brush Pen (brush & pen combined)
14. Chinese Brushes
15. Technical Pen Inks (black & colored)
16. Technical Pen
17. Dip Pen
18. Reed Pen
19. Quill Pen
20. Drawing Pen with Cartridge
21. Rollerball Pen
22. Ballpoint Pen
23. Fountain Pen
24. Brush Pen (flexible but solid nylon tip in various colors)
25. Fiber Tip Pen
26. Felt Tip Pen
27. Marker

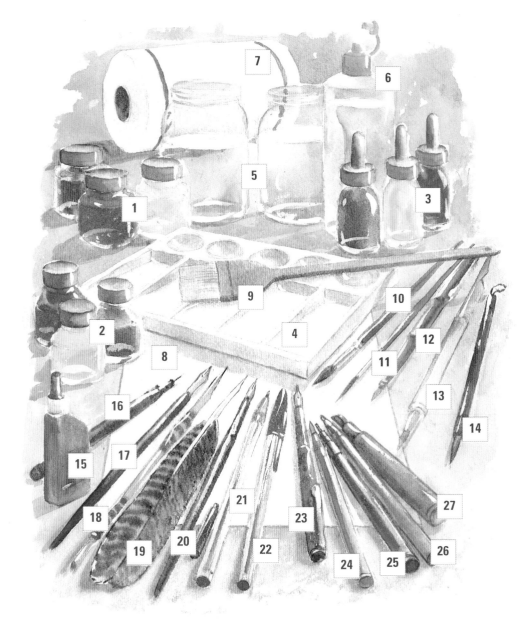

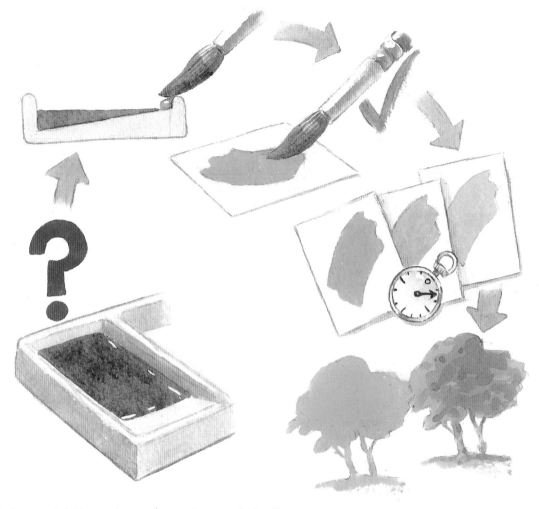

Understanding The Nature of Inks

In a deep-welled palette ink looks very dark and intense, which is very misleading, due to the depth of the pool of color. The resultant depth of color on the paper is quite different. Try out this simple test wash to check for the correct value.

Load the brush and wipe off excess ink by running along the rim of the palette. Draw the brush along a scrap piece of watercolor paper, using the side of the brush head, and keep it constantly in contact with the surface as the wash is applied. This gives a good feel of the value and intensity. Wait a few minutes and the wash will lighten and dull as it dries.

Do not be too disheartened if a wash of ink dries a little light. You can always build layers of wash, progressively darkening the values of selected areas. This particularly applies to waterproof ink, where it is better that the wash is too light rather than too dark; allowing you to control the application. Non-waterproof ink can be lifted by rewetting and dabbing with an absorbent tissue, the degree of lift being controlled by the absorbency of the paper as in watercolor.

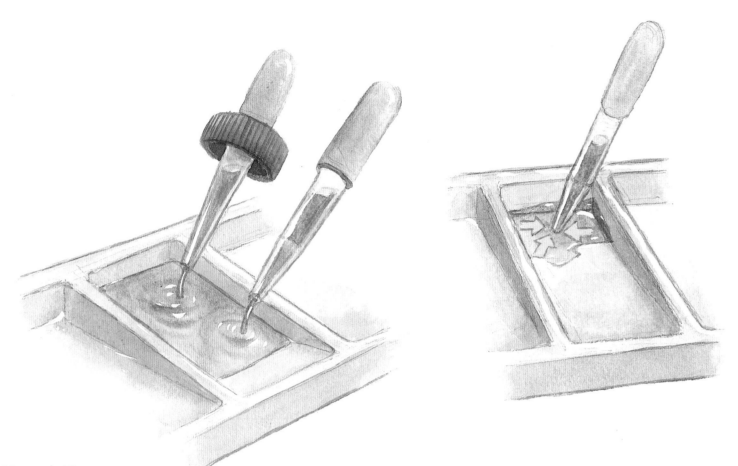

Hints & Tips

To ensure the reed pen is well loaded, the well of the palette must be generously filled with ink. Ink bottles that feature an integral dropper do the job of transferring ink swiftly and efficiently. For those without, use a separate dropper, which can also be used to add water to thin mixtures.

Put out much more ink than you will need, and once finished with, transfer back to the bottle, provided the ink has not been tainted or thinned down. In this way you will have exploited the maximum amount of ink with the minimum amount of waste.

MATERIALS
Stretched sheet of NOT Watercolor Paper
0.5mm 2B Lead Automatic Pencil
Nylon/Sable Round
Watercolor Brushes: Nos. 6, 8 & 10
2" (50mm) Hake Brush
Waterproof Inks: Range of Colors
Reed Pen • Ceramic Slant & Well Palette
Masking Fluid
Kneadable Putty Eraser

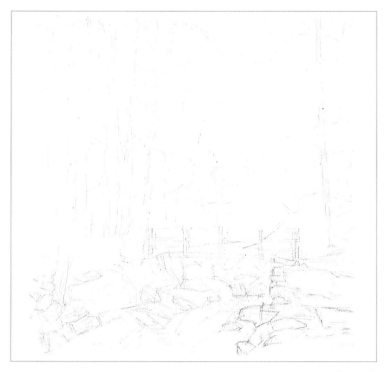

Step 1

Often a seemingly simple composition can be misleading, for simplicity demands an exact balance of the compositional elements. Luckily, the early pencil underdrawing can be reworked until correct since the ink line to follow will allow you to erase all preliminary drawing. This image is full of detail, which must be ignored in favor of attention to the relationship between the large masses and how they make the composition work. Keep in mind the background of trees, which covers two-thirds of the image. Here there is depth all the way to the mountain, which requires that particular attention be paid to overlapping leaf masses. The bridge, though flat on, is off-center, and the wall on the left side of the stream has height that should not be lost. The wall on the right is seen only as an irregular edge, whose irregular shapes must be retained.

Step 2

It is important that you are relaxed when starting on the ink line. All the pencil work is there to guide you, so try to forget about the permanency of the line. Do not start to worry about absolute accuracy; learn to enjoy the flow of the ink. A reed pen was used here, the point of which skates across the surface with great freedom. This sense of enjoyment is conveyed and expressed through the line itself. Start from the front of the composition so that objects are successfully overlapped. Once satisfied, clean up the composition by erasing the majority of the underlying pencil using the kneadable putty eraser. Retain only those guidelines that will prove useful, such as those around leaf platforms — which are to be treated with masking fluid.

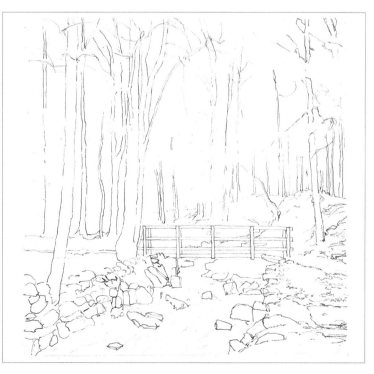

Hints & Tips

Under normal circumstances it is natural to start a drawing from the background to the foreground. Not only does it feel natural, but this would usually mean that you were working from the top of the page downward, and there is thus less likelihood of smearing or smudging freshly applied pencil or paint. Ink linework is the exception.

Since the ink line is permanent, erasing where one object meets another cannot be carried out. If the silhouette outline of one object can be seen through another, then suddenly the top object begins to look transparent, confusing the viewer. The sensation of depth caused by objects moving behind each other is lost.

Working from the front allows you to work from the edge of close objects, establishing the illusion of depth. If the linework is also made lighter by progressively adding water, then it is also sensible to start in the foreground with the full strength ink. This can then be gently thinned as it moves into the distance, enhancing the sense of aerial perspective.

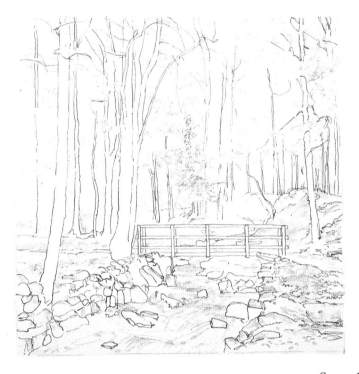

Step 3

Be generous with the application of masking fluid. Against the white of the paper it always looks more than it is, and excess can always be gently eroded when dry by rubbing with a finger. The mask is quite structural in this picture with its directional flows forming the leaf platforms (masses) and the horizontal lie of the ground. Note how it is scuffed across the foreground just as you would with paint to create light textures.

Step 4

Premixing with a little Neutral Gray softened the intensity of the yellow ink used here. Wet the surface throughout with a Hake. This is essential for large soft areas of ink; otherwise, the immediacy of the staining will create hard edges in the wrong places. Follow the first thin washes with a deeper wash of the same color while the surface is still wet. This establishes some darker values beneath leaf platforms and in the foreground wall and stones.

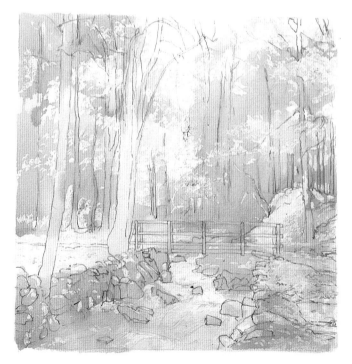

93

[A] Soft ink values achieved through applying the medium wet-on-wet.

[B] Linework now appears softer against the applied ink values but is, nevertheless, still visible across the whole image.

[C] Dry masking fluid can be seen beneath the ink. These areas take longer to dry, so take care when removing mask.

[D] Masked areas are made as irregular as possible. When applying strokes, imagine you are applying a light color; be both creative and structural.

[E] Shapes between the masked areas can also be thought of as important elements. If the masked areas were light colors, then the darker areas would be the "negative shapes." In this instance you are simply painting them first.

[F] Some soft areas of almost white paper are left to provide an atmospheric quality.

[G] Linework is left at full strength, even into the background. This will become part of the "line pattern," which will prove to become an important unifying influence in the final picture.

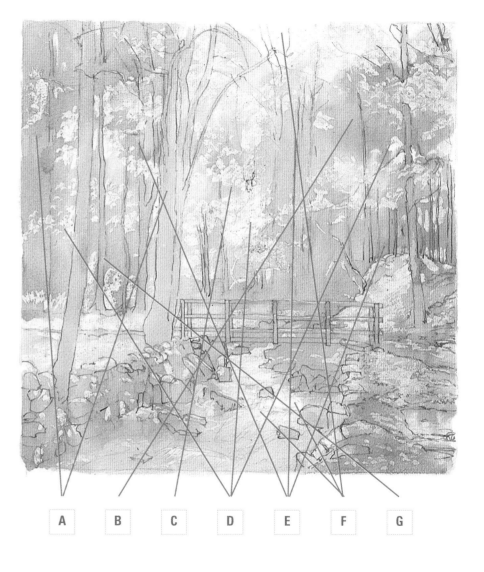

A B C D E F G

Step 5

In spite of the fact that
the ink glow is beautiful,
it still needs to be
reduced. The masked
areas are protecting the
white, which can be
colored brightly later. For
now, concentrate on the
soft colors around them,
which, if dulled now, will
provide suitable
contrasts. A dull but
warm mix of orange,
brick red, and more
neutral gray works well.
Applying wet-on-wet
color to small areas of an
ink rendering is much
easier than it would be if
you were working in
watercolors. Here there is
no need to worry about
dried color lifting.
Rewetting thus becomes a
dream, and you can wet
as much, or as little, of
the surface as you require
and rewet again and
again.

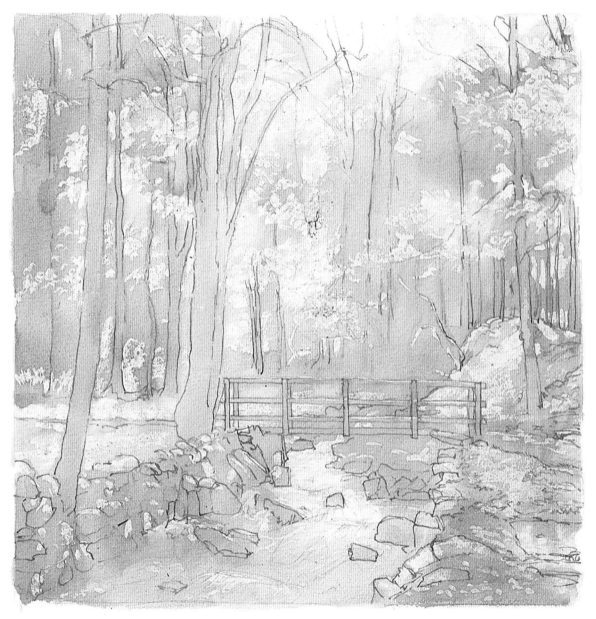

95

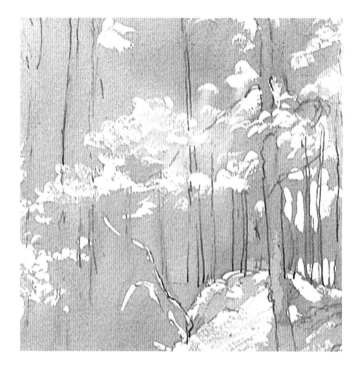

A R T S T R I P S

MASKING FLUID: Strokes painted over gaps in trunk will suggest leaf masses growing in front.

Strokes painted right up to edges of trunks will suggest leaf masses growing behind.

Restricted load on brush, held low to surface, will scuff on masking fluid to create texture.

Large areas can begin with a scuff. Silhouette can later be developed using small dabs or strokes.

Step 6

Gently lift masking fluid using the kneadable putty eraser. Now that the strokes of the mask are exposed you can see their structure and the variations of mark you will need to explore when you are at the point of applying it to your own painting.

Step 7

The highlight areas previously masked now need light solutions of color. Rewet the surface as you go along. Start in the center with a pure yellow, and move left, adding blue to create light green. To the right yellow and orange are mixed with pure orange applied across foliage and ground cover below. Both sky and water have a light coating of blue.

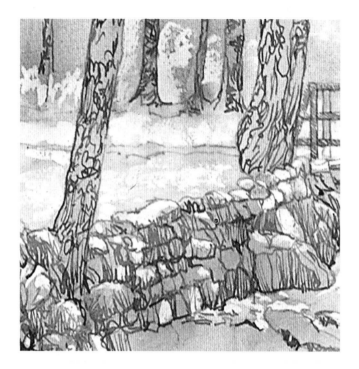

A R T S T R I P S

The angled well palette is excellent for loading the reed pen. Hold pen at low angle.

Tip palette to increase depth for small quantities of ink.

Hold pen at steep angle to the surface so ink runs to the tip. Increased flow ensures prolonged delivery of ink for detail.

Quite different line results from choosing to use pen either in a normal manner or reversed.

Step 8

The color washes and hard masked edges are describing so much about the image that you can now be very selective with the final linework. Enjoy the freedom of the reed pen, using the ink at full strength. Start with the foreground tree trunks with a mix of neutral gray, brown, and red-orange, maximizing their textures as you feel your way around the bark. Artist Paul Klee described drawing as "taking a line for a walk" and that is what you are doing here, discovering the surface and finding out what the line can do. Do not feel that you have to be logical with every line; let it flow and develop into patterns. If you are enjoying the experience, it will show through in the line quality. Add Indigo into the mix for distant branches, allowing trunks to appear and disappear behind leaf masses. Yellow in the mix produces a green for the stone wall in the foreground.

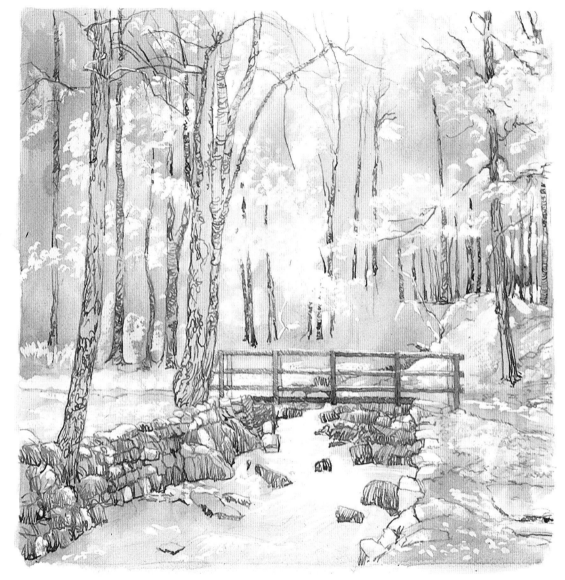

[A] Linework varies in color but is used at full strength. This encourages a strong overall pattern, a weave that holds the image together.

[B] The exception is the line in the water, which is let down into a weaker solution. This suggests transparency for the water against the more powerful line on the solid objects elsewhere.

[C] Here we break the rule "Never lead a diagonal from the corner of your picture." However, it works because the line along the bottom of the wall is broken and irregular, and the bridge halts the eye. The artist can be guided by rules but never restricted by them.

[D] Enjoy the patterns that the line creates. Do not be too literal by trying to capture every texture. Look for those that are dominant and remember that the spaces are as important as the lines.

[E] The green ink linework, like the mask, is drawn up to the edge of the trunk and then appears to move behind.

[F] The orange ink linework is drawn in front of the trunk, echoing the preceding mask.

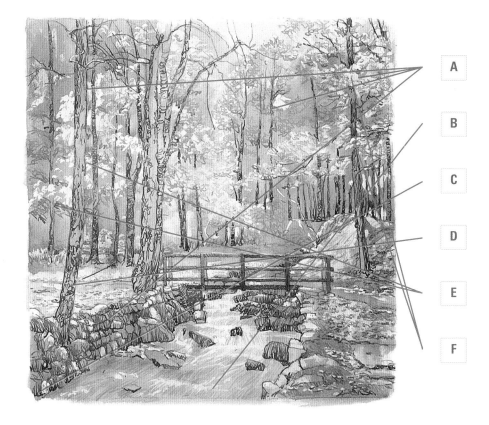

Step 9

Bright green and orange linework for leaf foliage is now used to unify the image. There is no need to cover every inch of the surface. Be selective to suggest the structure of the leaf platforms. Always remember that it is often what you leave out of a picture that makes it work. Suggestion is far better than over detailing. This fine line is achieved using the reverse of the pen point. For a soft line hatched across the water in light blue, use the pen point in its normal position.

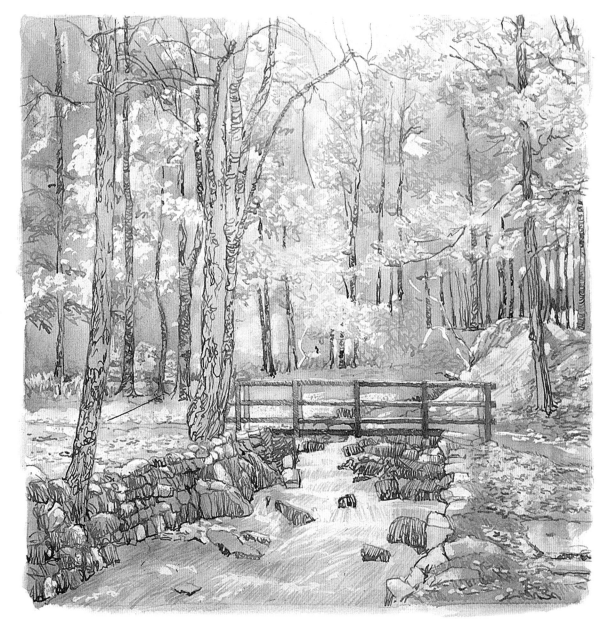

Color Palette

Working with color is always exciting and without exception, all newcomers to the pursuit of painting are so keen to get started that the very idea of understanding the science of color mixing seems unnecessary. This is a natural reaction, for creative people much prefer to get on with fulfilling their desire to create.

After all, with such wide color ranges available from so many paint manufacturers, it is surely just a matter of buying a particular color? Furthermore, if a mix were required, wouldn't a bit of this and a bit of that eventually produce the color?

I guarantee that much heartache and frustration will be avoided once you to get to grips with the basics of how color works. Being able to not only mix a specific color but also to balance the colors across the whole composition will give you a great sense of freedom.

The physical aspects of color mixing are just as important as the theory, if not more so. Imagine being in the middle of a painting; the paint is flowing and you reach for a color. It isn't there, or the top will not budge and in frustration you use another color, which turns out not to be appropriate. No matter how technically proficient you are, on this occasion you were simply not well enough prepared.

The first step toward successful color mixing is to understand the tools with which you will be working. Paint, palette and brushes have to work sympathetically if you are to control the results.

All artists grow to love their drawing and painting tools. By ensuring they are in perfect working order, the correct ones to complete the task and to hand in an instant, you will have prepared the way for an enjoyable and productive time ahead. Laying out the colors before you start is the most basic way in which this is achieved. An organized set of colors encourages an organized approach to the work.

A box of colored pencils laid out in the progression of the spectrum is a joy to use. One in which the pencils are all jumbled becomes a nightmare.

Twenty colors of oil paint on an oil palette will be confusing. Six laid out in order are an inspiration.

Organized color mixing also leads to clean color mixes. If you are confused, you will tend to mix everything together in the vain hope of success, all the while producing mud. Muddy colors are one of the most common problems experienced by those new to painting and by those who have not taken the time and trouble to understand color mixing.

This chapter deals with the organization of colors in a variety of media and is intended as a starting point. Inevitably you will evolve a method personally suited to yourself, one that allows you to carry, store, and use colors in an efficient manner.

Pastel Spectrum

There is nothing worse than facing a box full of scattered broken pastel pieces. Trying to find a particular color is impossible once they have broken up, intermingled and spread their color on to each other. Keeping the pastels in a specially designed, sponge lined box featuring sponge separators and individual covers provides one solution. Alternatively, make your own from two plastic trays (base & lid) lined with corrugated cardstock or shelf liner. Cut a piece of bubble wrap to line the lid and secure lid to the base with rubber bands.

Mixing of pastel colors is limited when compared to using paint, but they can be worked together on the surface, spread into one another using paper wipers or blenders, or layered over one another. To overcome mixing limitations, it is essential to build up a range of tints for each hue from very dark to light. Easy identification, cleanliness, and simple access are therefore a necessity, requiring you to be organized in the arrangement, storage, and transport of your pastel set. Arrange the pastels to match the flow of the color circle with the tints of each hue placed together so that a gradation of color values is easily accessed.

TERMS ESSENTIAL TO UNDERSTANDING COLOR MIXING
HUES
Bright primary and secondary colors are known as hues.
VALUE
Some hues are very light while others are dark = different values.
INTENSITY/CHROMA
Dull colors have a lower intensity than the bright ones.
TONE
The degree of lightness or darkness of a neutral gray.

Watercolors

PAN MIXING

A metal box of watercolor pans is a really worthwhile investment that should last a lifetime. Artists' Quality pans are preferable for they produce cleaner, more vibrant mixes and dissolve much more swiftly. The pans are pre-wrapped in a paper sleeve on which is printed the color name and other identification details. Some of these colors are so dark when dry that it helps to identify them at all times when color mixing. The simplest way is to keep the wrapping papers and tape them, either to the box or on a separate piece of cardstock cut to fit inside it. Arrange the pans to mimic the position of the colors on the color circle.

The lid of such a box usually seconds as a handy welled palette, especially when working outdoors. Begin by premixing a quantity of red, blue, and yellow so that your first light washes are part mixed before you start painting. You need to save time to get you going quickly in watercolor painting, as the surface dries so fast.

WELLED PALETTE MIXING

An oblong welled palette is excellent for large fluid watercolor mixes. The deep rectangular wells hold a good quantity of wash, and the sloped base provides the ideal surface along which to pull the brush to both shape and remove excess fluid from its head. The lip at the top of the slope is used for the same purpose. Circular wells take a good quantity of tube color, which is softened with the addition of water.

The sectioned saucer palette works well in situations where fewer mixes are required and provides excellent storage for a particular color mix that may be used later, saving valuable space from being taken up in the main palette. It is also ideal for use with masking fluid. Pour out a quantity in one section, moving on to the next when the content of the first becomes unworkable. Once all three wells have been used and the masking fluid has dried in all of them, clean out by simply peeling off the latex. Plastic versions of these palettes, although light to carry and suitable for use with watercolors and masking fluid, do not suit inks, which stain the plastic, nor acrylics, which set hard and become unmoveable.

Watercolors

FLAT PALETTE MIXING

When mixing tube colors, no one wants to waste time unscrewing tops and screwing them back on again. This palette is ideal for working with tube colors, featuring deep wells in which to squeeze out a good quantity of paint and a separate large flat area on which to create mixes. The paint is kept constantly softened by periodically adding a few drops of water into each well. There is no need to remove any paint from the wells at the end of the painting session; only clean the main mixing area. Any paints in the wells that dry out are easily re softened with the addition of a few drops of water. Thus nothing is wasted.

Using a limited palette and squeezing out a good quantity of paint is far more useful than small quantities of twenty colors. Mixes of the six basic colors will achieve

95% of the color mixes you will ever require. For anything else, acquire the color as it is needed.

To make mixing easier, the six colors should be laid out in the wells to mimic the flow of colors on the color circle. Thus the primaries that mix best to produce the bright

secondary will be close to each other. While you won't forget the position of the six colors, this layout does help to remind you of how the color circle works and how to make the most of the mixes, especially the complementaries.

NOTE: With its large, flat mixing area, this palette is particularly suitable when using the Wet on Wet technique.

Basic Color Circle

Almost every artist resists learning about color mixing in the early stages of their development. The basics, however, are simple, and once mastered will open up a world of difference to your painting. It is such a pleasure to be in charge of your color mixes. Not only can you match a color, you can also control the balance of hues and values across the whole composition. Suddenly, colors work for you and your paintings begin to sparkle. I advise painters to work using a basic palette of six colors, from which most colors can be mixed.

Three primary colors = red, yellow, blue. These primaries cannot be achieved by mixing. Only available directly from paint box.

Primary colors mixed together to make secondary colors. Red + yellow = orange Red + blue = purple Blue + yellow = green

Three primaries = basic constituents of color circle and painters palette.

Pure primaries do not exist. Mixes can be unexpectedly dull. (e.g. Cadmium Red and Prussian Blue should give purple, but actually produce a muddy gray color.)

Because all primaries are biased toward the secondary, they mix best. Compatible primaries used to make bright secondaries.

So basic color palette now extended to include two of each primary.
[1] Red-orange
[2] Red-purple
[3] Blue-purple
[4] Blue-green
[5] Yellow-green
[6] Yellow-orange

 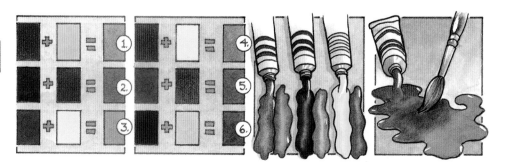

Close primaries mix to create bright secondary.
1+6 = orange
5+4 = green
3+2 = purple

Distant primaries mix to produce dull secondaries.
3+6 = dull green
5+2 = dull orange
4+1 = dull red

MIX CLOSE PRIMARIES, MIX DISTANT PRIMARIES
Complementary colors give tremendous contrast when placed next to each other, but mixed complementaries produce very dark, dull colors.

Color circle shows bright green, orange, and purple in place. Complementary color of each color on color circle sits opposite.

Tertiary color can also be complementary to its opposite on color circle.

When complementary colors are mixed, it amounts to all primaries being mixed...

...and resultant mix absorbs all light falling on it, giving black (or dull gray).

Before black is reached, colors progress through range of subtle changes. Try other complementary mixes to find position of differing browns and grays.

In early stages of learning to paint, draw out color circle to aid you with color mixing.

To change a color's hue, add another color near to it on the color circle. Add yellow to red and change its hue to orange.

To change its tone or value, add water or more of the same pigment to the mix....

...or its complementary.

If you add water as well as complementary to mix, the color will not become darker, only duller = change of intensity.

Adding white to a color produces a tint. Adding black produces a shade.

Tinting strength is the staining power of a color. (e.g. Equal amounts of Prussian blue and yellow mixed will not produce green — It will remain blue as Prussian blue has a powerful staining property.)

1. Inks

WELLED PALETTE MIXING

As inks can be mixed or diluted, deep wells are needed so that the stiff pen point can be fully immersed to ensure it is loaded with sufficient ink. Deep deposits also present a smaller surface area to the air, reducing the rate of evaporation. This is of utmost importance when using waterproof or acrylic ink that cannot be re dissolved once dry. Unused fluid inks may be replaced in the bottle from which they came, using the dropper that is incorporated into the lid of many of the makes. The slanted wells of the ceramic palette allow a loaded brush to be partially squeezed as it leaves the ink pool, ensuring the correct amount of ink is left in the brush head.

The ceramic saucer palette is equally well suited for inks. Indentations on the rim are useful for resting pen or brush while working, preventing either form rolling about on the work surface, thus reducing the chance of accidental spillage of water resistant fluid onto the work itself.

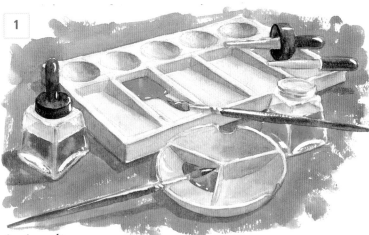

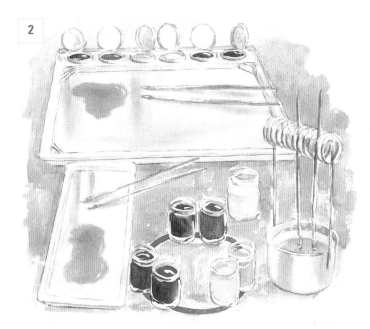

2. Acrylics

STAY-WET PALETTE MIXING

Although it is possible to mix acrylic paints on any non-absorbent surface, they tend to dry very swiftly and the paint soon becomes unworkable and thus wasted. A stay-wet palette is essential to keep the colors wet while you work, and a lid enables them to be kept until the next day. Make your own from two identically sized plastic trays, one as the palette, one as the lid. Line the palette with two sheets of blotting paper followed by two sheets of greaseproof paper that are cut to fit.

Brushes can also be laid onto this palette, thus reducing the chances of color drying into their hairs and consequently ruining the brush. At the very least, brushes should be protected by suspending them in water for short periods when not in immediate use.

Of great importance is the need to get sufficient quantities of paint out of the tube for swift access during the mixing process. The answer is paint containers with lids or mini glass jars with screw tops into which the paint is squeezed. Before sealing, add a few drops of water to retain moisture in the jar, ensuring the paint within keeps wet for some time. Mini glass jars are ideal, as they allow you to identify the color within and offer a sufficient depth of paint into which a brush can be dipped without touching the bottom. By keeping the jar topped up with paint, the quantity of air inside is minimised during storage.

Oils

LAYERED COLOR MIXING

In oil painting, not only do you have to concern yourself with mixing individual colors, you also have to understand how layers of color will interact. It is useful to limit the color range initially squeezed from the tubes onto the palette. This enables generous heaps of color to be deposited, ensuring there is no need to constantly open tubes, and it also encourages you to build up deep layers of impasto paint, the unique quality of oil painting.

The colors should be laid out along one outer edge; the one that runs on the opposite side to the edge that is more likely to come into contact with your body when the palette is held in your hand. The six colors should mimic the order in which they appear on the color circle to make mixing easier. The best order in which to arrange the colors is achieved through imagining the color circle split and laid out in a line. This also shows that they naturally lie in an order that darkens in value toward the left.

White is used in large quantities in oil painting, and a very generous amount should be squeezed onto the palette.

Thinning is also of paramount importance when working in this medium both for creating fluid paint and in surface mixing as transparent layers of color are overlaid. Quantities of these can be transferred from the main containers to dippers, which are clipped to one edge of the palette. Lidded versions are preferable as they enable the thinners to be stored and carried safely.

ART TECHNIQUES FROM PENCIL TO PAINT
by *Paul Taggart*

Based on techniques, this series of books takes readers through the natural
progression from drawing to painting and shows the common
effects that can be achieved by each of the principal media, using a variety of techniques.

Each book features six main sections comprising of exercises and tutorials
worked in the principle media. Supportive sections on materials and tips,
plus color mixing, complete these workshop-style books.

Book 1
LINE TO STROKE

Book 2
LINE & WASH

Book 3
TEXTURES & EFFECTS

Book 4
LIGHT & SHADE

Book 5
SKETCH & COLOR

Book 6
BRUSH & COLOR

ACKNOWLEDGMENTS

There are key people in my life whom have inspired me over many, many years,
and to them I extend my undiminishing heartfelt thanks.
Others have more recently entered the realms of those in whom I place my trust and I am privileged to know them.
Staunch collectors of my work have never wavered in their support,
which has enabled me to continue to produce a body of collectable work,
along with the tutorial material that is needed for books such as this series.
I will never cease to tutor, for the joy of sharing my passion for painting is irreplaceable
and nothing gives me greater pleasure than to know that others are also benefiting from the experience.

INFORMATION

Art Workshop With Paul Taggart is the banner under which Paul Taggart offers a variety of learning aids,
projects and events. In addition to books, videos and home-study packs, these include painting courses,
painting days out, painting house parties and painting holidays.

ART WORKSHOP WITH PAUL

Log on to the artworkshopwithpaul.com website for on-site tutorials
and a host of other information relating to working with
watercolors, oils, acrylics, pastels, drawing and other media.
http://www.artworkshopwithpaul.com

To receive further and future information write to:-
Art Workshop With Paul Taggart / PTP
Promark
Studio 282, 24 Station Square
Inverness, Scotland
IV1 1LD
E-Mail : mail@artworkshopwithpaul.com

ART WORKSHOP WITH PAUL TAGGART
Tuition & Guidance for the Artist in Everyone